Images of Modern America

VIRGINIA-HIGHLAND

Virginia-Highland Civic Association

VIRGINIA-HIGHLAND CIVIC ASSOCIATION

VIRGINIA-HIGHLAND CIVIC ASSOCIATION

Faced with a highway that threatened to destroy the community, a determined group of citizens organized the Virginia-Highland Civic Association (VHCA) and joined their neighbors in a spirited and successful fight against the powerful Georgia Highway Department. Mary Drolet designed the original VHCA logo (top left) to symbolize a new day in the neighborhood. (Courtesy of Mary Drolet and VHCA.)

FRONT COVER: Every June, Summerfest brings residents and business owners together for a weekend celebration that features a neighborhood dinner, parade, road race, food and drinks, an artists market, and music. (Courtesy of Blueskye Aerial Media.)

UPPER BACK COVER: Spring at the intersection of North Highland and Virginia Avenues (Courtesy of Drew Graham.)

LOWER BACK COVER (from left to right): Summerfest community movie (Courtesy of Lola Carlisle), Summerfest Tot Trot (Courtesy of Lola Carlisle), intersection of North Highland and Virginia Avenues in 1984 (Courtesy of Doug Hoffman and Jan Silverstein.)

Images of Modern America

VIRGINIA-HIGHLAND

LOLA CARLISLE AND JACK WHITE

ARCADIA
PUBLISHING

Copyright © 2018 by Lola Carlisle and Jack White
ISBN 978-1-4671-2855-1

Published by Arcadia Publishing
Charleston, South Carolina

Printed in the United States of America

Library of Congress Control Number: 2017955401

For all general information, please contact Arcadia Publishing:
Telephone 843-853-2070
Fax 843-853-0044
E-mail sales@arcadiapublishing.com
For customer service and orders:
Toll-Free 1-888-313-2665

Visit us on the Internet at www.arcadiapublishing.com

This book is dedicated to Tommy, Carli, Anna, Ben, Madeleine, Maya, Pierce, Parker, Sierra, and the future generations we hope will continue to treasure and protect this neighborhood.

CONTENTS

ACKNOWLEDGMENTS

Thanks go to Karri Hobson-Pape, our research partner and editor, who kicked off this great adventure. We appreciate the contributions and insights of Raymond Keen and Amy Reel.

Tommy and Pierce, thank you for letting us make the community history such a big part of our family life. Carli, Anna, Ben, Parker, and Sierra, may you and your friends always appreciate the special neighborhood where you grew up. No one was more on top of this manuscript than Rex; we appreciate it very much.

Thank-yous go to Tailfin Marketing, especially Erin Fagan, Matt Mewis, Liz Nobels, Lynn Strickland, Caroline Baron, and Camille Wolf.

Anna Benvenue and Daisy Gould provided thoughtful editing and proofreading.

John Becker, Peggy Berg, David Brandenberger, Lauren Wilkes Fralick, Emily Gilbert, Paige Hewell, Catherine Lewis, Pamela Papner, Robin Ragland, Angelika Taylor, and Jess Windham Liddick: You have a special place in the history of this neighborhood. Your calm and rational approach to a variety of challenges was remarkable.

Aaron Fortner's and Robert Zoeckler's vision and determination to preserve intown communities have made a remarkable impact in Virginia-Highland. Daniel Moriarty has provided learned and patient counsel to this community on numerous occasions. We are grateful to all three of these individuals.

This book was assembled with the help of hundreds of people who have shared their stories, time, and passion. Our thanks go to Atlanta Public Schools (APS), Ann Taylor Boutwell, Eleanor Downs Callaham, Jennifer Chambers, Tim Crimmins, Mary Davis, Joseph Drolet, Mary Drolet, Blake Cheshire Liddell, Ramona Liddell, Debora Liddell, Drew Cheshire Liddell, Adele Northrup, Chris Bagby, Sharon Bagby, George and Judy Beasley, Jerry Bright, Sandra Spoon, Stephanie and Tom Coffin, Tracy Crowley, Lynn DeWitt, Jackie Fleeman Gramatas, Kim Griffin, Peter Frawley, Nancy Hamilton, Few Hembree, Shirley Hollberg, Nan Hunter, Patricia Jayne, Alan and Barbara Kaplan, Susan Kraham, Cliff Kuhn, Judy Kuniansky, Rob Lamy, Kerry Marchman, Beth and Jett Marks, Sheryl and Stuart Meddin, Linda Merrill, Tom Murphy, G.G. Najour, Gail Novak, Polly Price, Sue Powers, Herbert Ray Jr., Chip Simone, Mary Stouffer, Craig Strain, Todd family descendants, Cubby Ware, Mary Alice Ware, Herb Wollner, Jane Little Yelton, and many more.

In May 2017, the Virginia-Highland Historical Society was founded by a team of individuals that care deeply about preserving the history of this community for the next generations. The founding members were Lola Carlisle, Karri Hobson-Pape, Raymond Keen, Catherine Lewis, Jess Windham Liddick, Judy Potter, and Jack White.

INTRODUCTION

The neighborhood of Virginia-Highland was bucolic and reassuring to those who returned to it after World War II. The appearance of the housing—mostly built between 1900 and 1930—had changed little, other than the growth of the remarkable collection of trees. The apartment buildings clustered near Ponce de Leon and the trolley line on Highland Avenue sat peacefully amidst single-family homes. While those homes had been built by a series of different developers, most were single-story bungalows with porches and small front yards that encouraged interaction with neighbors. The goods and services necessary for everyday life—groceries, drugstores, restaurants, and bars—were within walking distance for most citizens. Many of those businesses were owner-operated, often by residents who lived nearby.

Almost all the residents were white. From the beginning, most developers had included restrictive racial covenants as a condition of purchase. A variety of religious denominations—Baptist, Episcopal, Jewish, Methodist, and Presbyterian—worshipped locally.

Schools were also segregated by sex. The neighborhood's male children went to one of two high schools—Boys High and Tech High—located next to each other just yards from the neighborhood's western edge. Females traveled—many on city buses—to old Girls High, near Grant Park. Though not a mile of expressway yet existed in Atlanta, the streetcar line that had served Virginia-Highland for decades would soon be taken out of service, signaling a postwar wave of auto dominance that would itself later threaten the community.

The social order that had been dominant since the post-Reconstruction era was in place. Many of the wartime jobs held by women were surrendered to men returning to the workforce. Gay citizens carefully concealed their sexuality. But a new postwar world was about to emerge—one that was broader, more democratic, and much more interesting.

African Americans returning from a war in which they had risked their lives and fought bravely and effectively were much less willing to accept the indignities and slights of second-class citizenship. Atlanta's police force integrated grudgingly in 1949. Though black officers could not arrest whites at first, they were now on the force and the direction was irreversible. The Supreme Court's decision in *Brown v. Board of Education* in 1954 culminated a long battle to legally overturn segregation in public schools, and it began a new and bitter one to enforce it.

The 1958 bombing of The Temple in nearby Midtown signaled the coming challenges. It came amidst the burgeoning civil rights movement and the efforts of many (still all white male) Georgia state legislators to close the state's schools rather than integrate them. By 1960, Martin Luther King Jr. had moved to Atlanta, and students from Atlanta's historically black colleges were defying their own parents and leading a movement that would integrate downtown businesses.

The signs of change were everywhere, but—insulated by space and inertia—northeast Atlanta had so far encountered few of them.

As a region, it had not yet suffered any appreciable migration to the suburbs. Buoyed by a rising standard of living and record expenditures on public schools, it was in the midst of producing one of the best-educated generations in the nation's history.

That all those students and their faculty were white—as were the patrons of nearby Piedmont Park, the city's largest—was still considered unremarkable. The essential patterns of social life moved along drowsily in familiar patterns.

It was all about to change, slowly at first and then very noticeably. The decades after the *Brown* decision would be as locally tumultuous as the previous had been quiet. In that period, the Georgia Highway Department proposed and tried to build a massive new interstate right through the neighborhood to speed residents of the booming suburbs to and from downtown. Dozens of historic homes were torn down in the process. Atlanta's schools were formally integrated in 1961, slowly at first and without overt violence. But in the late 1960s, white enrollment across the city fell sharply as baby boomers aged out and the suburbs boomed.

The mid-1960s opposition to the Vietnam War and the emerging counterculture both found homes in Piedmont Park, which—with nearby 10th Street and Peachtree—attracted disaffected young people from across the Southeast. Many of them moved into the rapidly devaluing housing that was readily available to those willing to live with an interstate highway as a neighbor.

The very existence of the community was in danger; from every angle, its survival as an identifiable entity was unlikely. By the mid-1970s, some of its once crowded public schools were being shuttered.

But survive it did. How it did—the story of the challenges it faced, the struggles and responses to them, and the new community that emerged in the decades that followed—is the topic of this book.

A mix of new arrivals and remaining citizens, many of them young and female, led an increasingly organized and energetic grassroots fight against a startled Georgia Highway Department, which was used to building roads but not to justifying them.

The very idea of opposing (much less stopping) a new highway in Georgia seemed quixotic. The Georgia Highway Department was an enormously powerful political institution that had never faced massive public opposition and had its own constitutional source of funding. The men who ran it—and they were all men—were supremely confident of the righteousness of their own work, irritated by public input, and scornful of the notion that giant highways were environmentally degrading and destructive to civic life. Stopping the road saved the community physically and (un)paved the way for a similarly successful—and even more bitter—fight a decade later against the nearby Stone Mountain Freeway. The process of organizing a new civic group from scratch necessitated mobilizing help and contributions from all sectors of the citizenry. Many of the women and men who found their voices in the highway battle remained active over the next quarter century, particularly in planning issues. They notably included women who moved into public office and many openly gay citizens who asserted their own political rights and pride in their culture. Some of the land cleared for the highway would be transformed into a new public park memorializing the struggle against AIDS.

In this diverse and relaxed atmosphere, alternative lifestyles and art of all kinds emerged and flourished. The residential community was rebuilt and a struggling commercial district found success. A remarkably creative and energetic group of citizens emerged. The local public schools soon faced a different attendance problem: the repeated need to expand their capacity.

The neighborhood whose very existence was in doubt in the late 1960s is now coping with how to sustain and protect the features that it fought so hard to preserve.

It has been a strange and interesting journey, one full of joy, hope, despair, humor, and irony. We hope you enjoy our telling of it.

One

POST–WORLD WAR II

BOOMING IN NORTHEAST ATLANTA

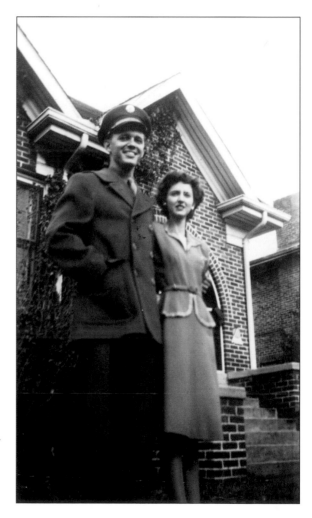

The return of soldiers from World War II brought a baby boom and a demand for more housing. The mostly built-out community experienced a spurt of infill development and added some new apartment units. School enrollments expanded dramatically; the Atlanta Public Schools system was soon short of seats. (Courtesy of Lucy Crenshaw.)

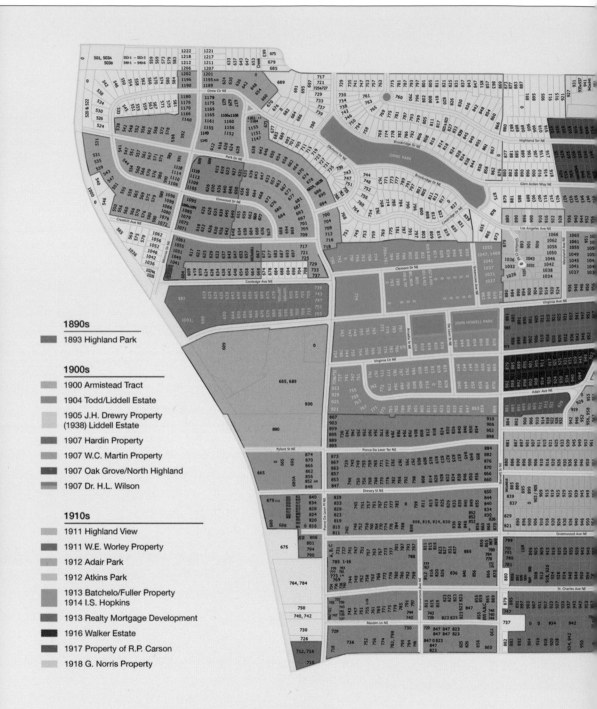

1890s

1893 Highland Park

1900s

1900 Armistead Tract

1904 Todd/Liddell Estate

1905 J.H. Drewry Property
(1938) Liddell Estate

1907 Hardin Property

1907 W.C. Martin Property

1907 Oak Grove/North Highland

1907 Dr. H.L. Wilson

1910s

1911 Highland View

1911 W.E. Worley Property

1912 Adair Park

1912 Atkins Park

1913 Batchelo/Fuller Property
1914 I.S. Hopkins

1913 Realty Mortgage Development

1916 Walker Estate

1917 Property of R.P. Carson

1918 G. Norris Property

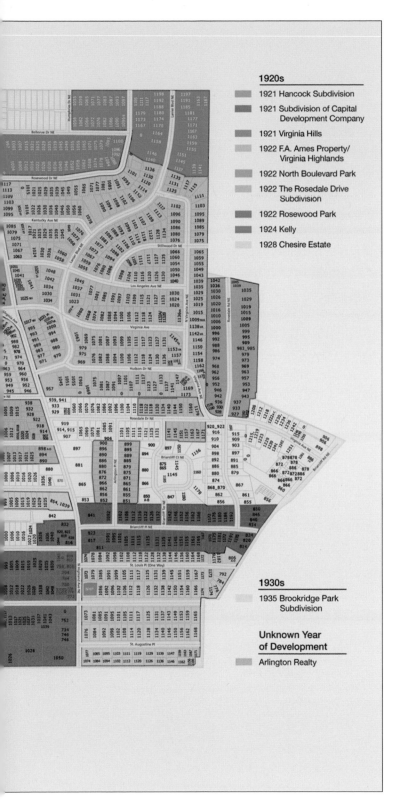

1920s

- 1921 Hancock Subdivision
- 1921 Subdivision of Capital Development Company
- 1921 Virginia Hills
- 1922 F.A. Ames Property/ Virginia Highlands
- 1922 North Boulevard Park
- 1922 The Rosedale Drive Subdivision
- 1922 Rosewood Park
- 1924 Kelly
- 1928 Chesire Estate

1930s

- 1935 Brookridge Park Subdivision

Unknown Year of Development

- Arlington Realty

The area currently recognized as Virginia-Highland is composed of nearly 20 distinct development projects, mostly built between 1890 and 1940. The intermittent construction pattern explains why some streets are offset (Drewry Street at Barnett Street is an example) and why some developments have a curvilinear layout and others a grid. The development pattern predominantly followed Highland Avenue south to north, along the line of the Nine Mile Trolley. Areas more distant from that route generally developed later. Highland Avenue's early development—augmented by marketing that compared it to Druid Hills to the east—made that road synonymous with the area for many decades. (Courtesy of Virginia-Highland Historical Society.)

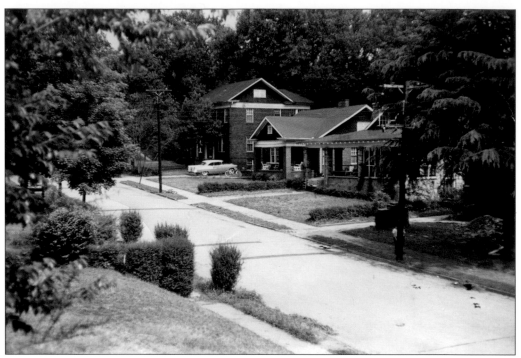

Cleared for farmland in the 19th century, northeast Atlanta was built out along the streetcar lines constructed in the early 1900s. The streetcars defined the layout and characteristics of the new communities around them. Most homes in the area were single-family, but from the beginning, there were a number of multifamily dwellings. Styles of architecture were predominantly Colonial Revival, Craftsman, Dutch Colonial Revival, English Vernacular Revival, Mediterranean Revival, and Neoclassical Revival. Narrow lots minimized the distance to streetcar stops. Alleys behind the lots provided service entrances for deliveries as well as access for the domestic servants common to the era. Trees were carefully cultivated along the sidewalks for shade and visual appeal. (Above, courtesy of Jenny Chambers; below, courtesy of Special Collections and Archives, Georgia State University Library.)

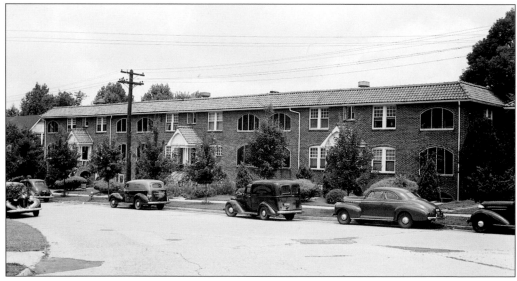

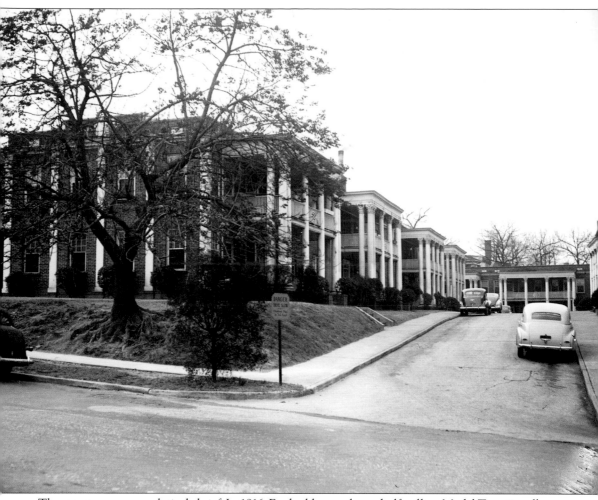

The streetcar era was relatively brief. In 1916, Ford sold more than a half million Model Ts nationally. By the mid-1920s, the automobile's increased mobility made housing away from downtown practical for those who could afford it. Then suburban Virginia-Highland was substantially built out in this period. By 1930, the volume of autos and the congestion they created were articulated civic concerns in Atlanta, an early sign of the transportation challenges that continue to plague the metro area to this day. The first impacts in Virginia-Highland were subtle; houses in Virginia-Highland built with narrow or no driveways began to be modified to accommodate cars. This photograph shows apartments built on Virginia Avenue when space for cars was not a dominant design feature. The last streetcar ran in Atlanta in 1949. The trolley barns built on Virginia Avenue in 1888 for streetcar construction and maintenance survived for a century; efforts to preserve them failed in 1988 by one vote at city council. They were replaced by the Virginia Highlands Apartments. (Courtesy of Special Collections and Archives, Georgia State University Library.)

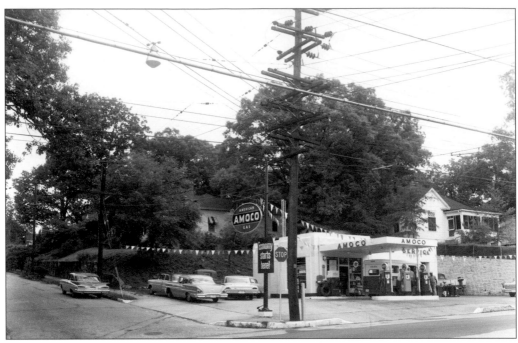

North Highland Avenue had half a dozen gas stations in the postwar years. An Amoco station (above, in 1960) sat across from today's post office; a Gulf station (predecessor of today's Chevron at Virginia and Highland Avenues) flanked a Standard Oil (later a Texaco) run by Hoke Herrington on the property now occupied by Yeah Burger. A Hess station on the corner of Briarcliff Place and a Pure Oil at Drewry Street (pictured below) operated into the 1970s and 1980s, respectively. Environmental regulations and increasing property values made other uses more profitable. The Chevron is now the neighborhood's only gasoline retailer. The neighborhood commercial zoning adopted for Highland Avenue in 2009 limits the number of gas stations on Highland Avenue to one. (Above, courtesy of Special Collections and Archives, Georgia State University Library; below, courtesy of J.R. and Kerry Marchman and Justin Haynie.)

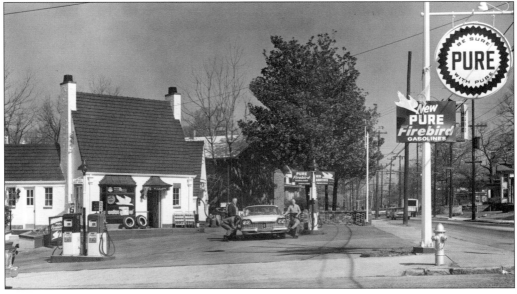

Single-sex education was common in public schools well into the 20th century and endured for Atlanta's white children until after World War II. The school system had historically taught males at either Boys High or Tech High (located beside each other at Parkway Drive and Eighth Street); white females went to Girls High in Grant Park. In 1948, Atlanta Public Schools went to a neighborhood-based system to reduce the distances that children traveled. Virginia-Highland children attended newly renamed Grady High, whose campus combined all of Boys' and Tech's facilities. Less than two miles to the south, black students attended David Howard High School. In 1954, racial separation was struck down by the US Supreme Court, which ordered that racial segregation be ended "with all deliberate speed," an oxymoron that the South certainly embraced. (Above, courtesy of Eddie Ware; right, courtesy of Grady High School *Orator*.)

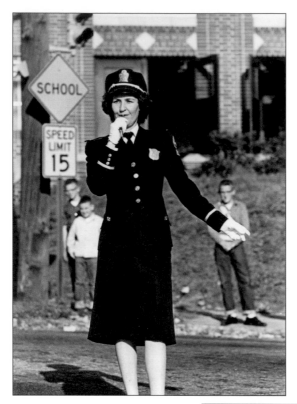

Built as Virginia Avenue Elementary School in 1923, Samuel Inman Elementary School (left) was designed for 630 students. Foreshadowing the overcrowding it would face decades later, over 1,000 children arrived on the first day. Popular for a half century, Inman suffered from declining enrollment during white Atlanta's flight from public education in the 1970s. Nearby Bass, O'Keefe, and Forrest Avenue Elementary Schools closed. Morningside and C.W. Hill (in Bedford Pine) were combined; grades one through three went to C.W. Hill, grades four and five to Morningside. Inman became a middle school in 1978. Within 10 years, enrollment began to rebound, and by 2000, Inman required expansion, a challenge it faced repeatedly over the next decade. As years progressed, not-so-temporary trailers filled much of its former recreation space, as seen by the black rooftops below in 2017. (Left, courtesy of J.R. and Kerry Marchman; below, courtesy of Blueskye Aerial Media.)

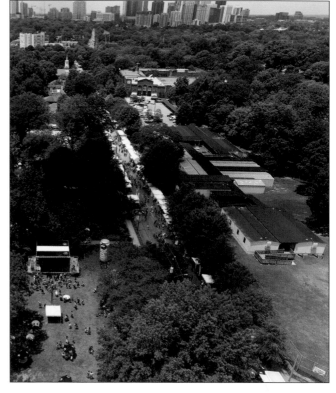

In the 1940s, Tandy K. Downs Jr. managed a popular A&P on Highland Avenue, opposite Moe's & Joe's. Downs grew up in Grant Park and went to Georgia Tech. His daughter "Bootsie" is at left in the above 1940 photograph of their apartment building at 993 North Highland Avenue. Downs's parents owned the house at 1002 North Highland Avenue; in the 1950s, they sold it to Dr. Marvin Kaplan, who practiced dentistry there until 2009. The A&P eventually moved to a larger location on Highland Avenue (next to Alon's) before closing in the 1970s. As a child, Bootsie saw *Gone with the Wind* at the Hilan Theater and took a weekly dance class at Inman Elementary taught by Dorothy Alexander, founder of the Atlanta Ballet, the nation's oldest ballet company. (Both, courtesy of Eleanor Downs Callaham.)

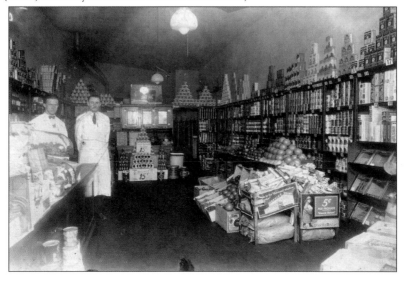

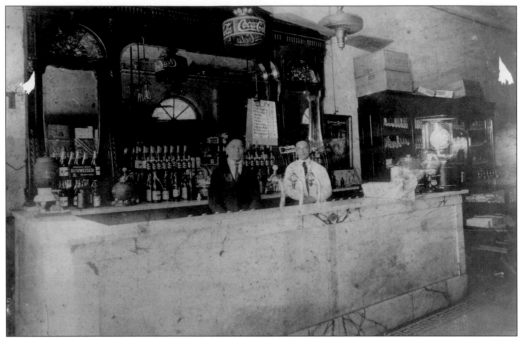

Atkins Park Restaurant and Bar is the oldest continuously licensed bar in Atlanta. Built as a home in 1910, the structure was raised 20 feet a decade later and a deli was added below. The bar was a classic (sometimes boisterous) watering hole for decades and continued plugging along in the 1970s as a hangout for painters and construction workers. In 1983, Warren Bruno—a family man with enormous energy and numerous community connections—transformed it into a popular bar and neighborhood restaurant. Under the leadership of Bruno and his wife, Sandra Spoon, who continues to run the business since Bruno's death in 2012, Atkins Park became an iconic destination and remains an anchor business on the southern end of Highland Avenue. (Above, courtesy of Warren Bruno, Sandra Spoon; below, courtesy of John Becker.)

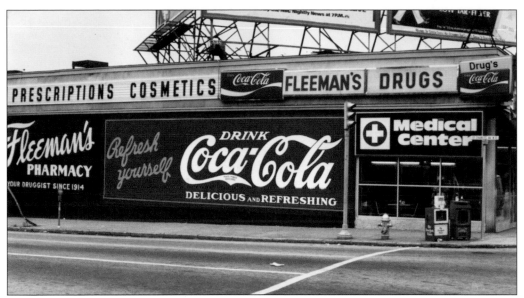

Jack Fleeman started as a curb boy at Cox & Baucom at the corner of Highland and St. Charles Avenues and took over the business in the late 1940s. Renamed Fleeman's Pharmacy, it was a classic soda fountain shop, offering chocolate, lime, and even celery-flavored Coca-Cola. In 1982, the building's original windows were bricked and featured advertisements that included a vintage-style Coca-Cola mural (above). Farther north on the same road, Hilan Theater was built in 1933 by Louis Bach, an Atlanta showman. After the theater closed in 1969, the large space was occupied for many years by the Metropolitan Community Church, one of the first congregations that openly welcomed worshipers of all sexual orientation. The space later became the City Church Eastside. (Both, courtesy of Jackie Fleeman Gramatas.)

HILAN Theatre
800 N. Highland ave. N.E. TR 2-7946

Storey THEATRES

ACCT _____ adv.

Void After _____ July 25/65

_____ Terry W. Holman
MANAGER

NOT GOOD ON SATURDAYS, SUNDAYS, HOLIDAYS, HOLIDAY EVES, OR ADVANCED ADMISSION PERFORMANCES

NOT TRANSFERABLE

EXCHANGE FOR TICKET AT BOX OFFICE

Brothers Moe and Joe Krinsky returned from World War II and opened Moe's & Joe's in 1947. The bar has been a hangout for many residents and Emory students for decades. The enormously popular Horace McKennie worked there for 52 years, attired each day in a bow tie, suspenders, and formal jacket. A mural of him now adorns the south side of the building. (Courtesy of Dani Miller.)

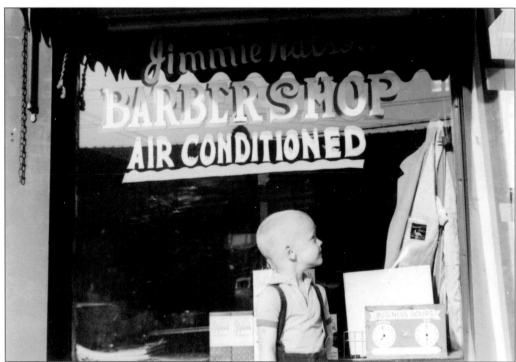

Jane Little Yelton's father, Henry Little, was a barber at Jimmie Watson's Barber Shop (1004 Virginia Avenue) for decades. Jane enjoyed the shops along Virginia Avenue and worked at Baumgarten's as a teen. A student of Grady High School in 1961, Jane recalls Principal Derthick's advice for interaction with the newly admitted black students: be polite but keep the conversations short. Her locker was next to Lawrence Jefferson's; they cordially greeted each morning. (Courtesy of J.R. and Kerry Marchman.)

William and Hermina Spielberger bought the new home at 1025 North Virginia Avenue in 1939. Their daughter Fannie Mendle Boorstein later purchased it from them; her son Ronnie lived there until his death in 2000. The Boorsteins owned F&M Variety Store on North Highland Avenue. Fannie Boorstein (right, center) played a key role in founding the William Breman Jewish Home in 1951. (Courtesy of Herb Wollner.)

A dozen Protestant churches and synagogues dominated religious life in Morningside and Virginia-Highland after World War II. Two churches—Druid Hills Baptist and Virginia-Highland Baptist—flourished for decades but lost members steadily after 1970. The conservative tilt of the Southern Baptist Convention prompted both churches to end their affiliation. Druid Hills Baptist changed its name to the Church at Ponce & Highland and sold part of its land. (Courtesy of Dani Miller.)

Founded in the mid-1920s, Church of Our Saviour expanded in the 1950s; the original wooden siding was covered by brick. A generation of theological and social conservatism ended in 2006 when Fr. John Bolton became priest-in-charge. He immediately ended the use of the 1928 version of the Book of Common Prayer and built close ties with community and social groups, including the VHCA, AA, and food pantries. (Courtesy of Lola Carlisle.)

Druid Hills United Methodist Church, at the intersection of Ponce and Briarcliff Road, was founded in 1910. Membership declined in the 1970s and 1980s, and the congregation merged with Epworth United Methodist Church in Candler Park in 2016. Its preschool programming was very popular with intown families in the quarter century prior to the merger. (Courtesy of Steve Spetseris.)

Two

WINDS OF CHANGE

CIVIL RIGHTS AND THE THREAT OF I-485

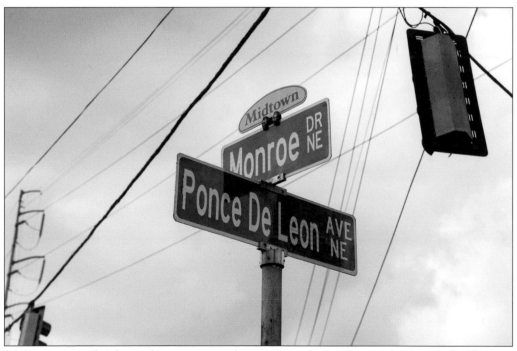

Resistance to civil rights and integration took many forms, both substantial and symbolic. Parkway Drive became Charles Allen Drive, differentiating the white sections of that road from black ones south of Ponce de Leon Avenue, a practice that dates back to 1937 when North Boulevard became Monroe Drive. (Courtesy of Nic Huey.)

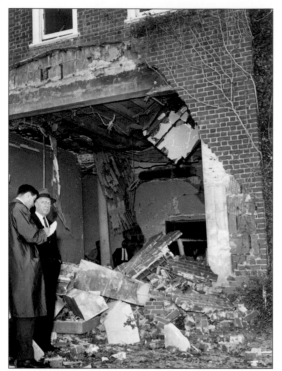

The 1958 bombing of Atlanta's largest Jewish congregation (left), The Temple, underscored the city's mounting struggles with challenges to the old order. It drew both national attention and a vigorous public response from then mayor William Hartsfield. As African American parents and organizations pressed Atlanta's schools to integrate, Govs. Marvin Griffin and Ernest Vandiver threatened a statewide shutdown of the state's public schools. Vandiver eventually appointed a 14-member commission, chaired by Atlanta attorney John Sibley. Sibley was quite conservative but believed that resistance to federal law was futile and might destroy the state politically. The commission's statewide meetings, including one at Grady High School (below), attracted many segregationists, but Sibley's report recommended not contesting federal court decisions to integrate and provided several strategies for local school boards to delay integration. (Both, courtesy of AP/AJC.)

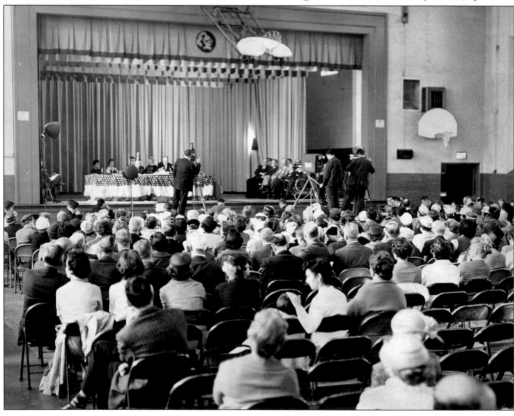

Atlanta peacefully integrated four high schools in 1961. Students Lawrence Jefferson and Mary James McMullen-Francis are shown walking toward Grady High School in this photograph from August of that year. The process's absence of violence—a dramatic contrast to similar events in Arkansas and other southern states—drew nationwide praise and became a bedrock of the civic boosterism embodied in the slogan "The City Too Busy to Hate." But in south and west Atlanta, many white residents—spurred on by blockbusting real estate agents—left the newly integrated schools in droves. Grady High remained overwhelmingly white until the late 1960s. Grady's 1962 yearbook (below) addresses the topic of desegregation once—and with great delicacy. (Right, courtesy of AP/AJC; below, courtesy of Grady High School *Orator*.)

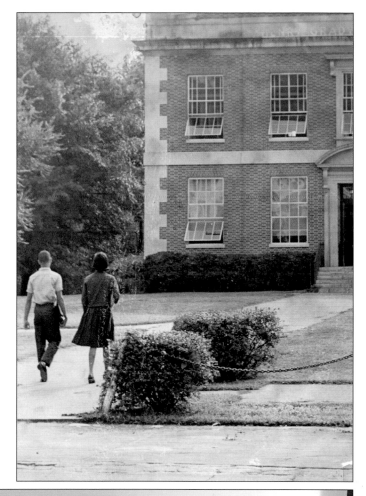

School begins anew. The first few days are filled with the excitement of renewed friendships, the scheduling and the coming of football season. Students are alert and lively from summer's rest. This year there was a slight difficulty in the reopening of schools, but students upheld the honor of Grady in peaceful desegregation of public schools.

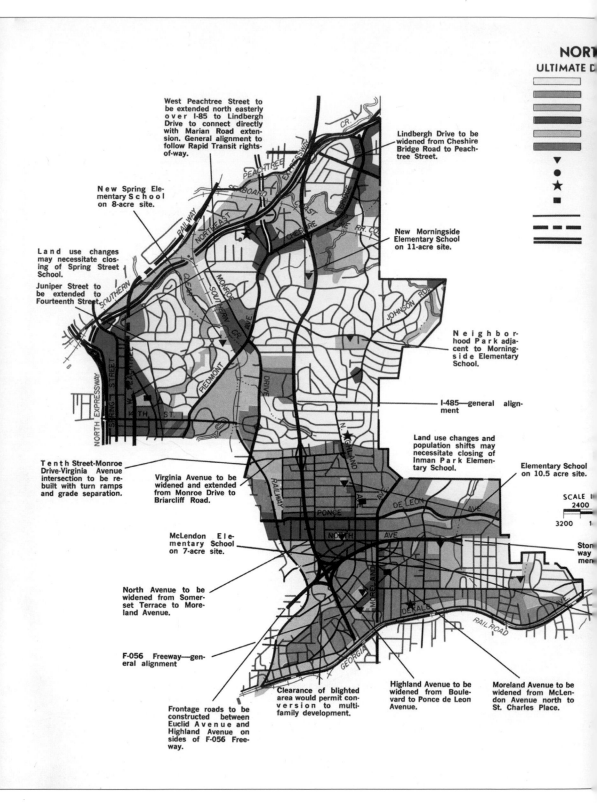

West Peachtree Street to be extended north easterly over I-85 to Lindbergh Drive to connect directly with Marian Road extension. General alignment to follow Rapid Transit rights-of-way.

New Spring Elementary School on 8-acre site.

Land use changes may necessitate closing of Spring Street School.

Juniper Street to be extended to Fourteenth Street.

Lindbergh Drive to be widened from Cheshire Bridge Road to Peachtree Street.

New Morningside Elementary School on 11-acre site.

Neighborhood Park adjacent to Morningside Elementary School.

I-485—general alignment

Land use changes and population shifts may necessitate closing of Inman Park Elementary School.

Elementary School on 10.5 acre site.

Tenth Street-Monroe Drive-Virginia Avenue intersection to be rebuilt with turn ramps and grade separation.

Virginia Avenue to be widened and extended from Monroe Drive to Briarcliff Road.

McLendon Elementary School on 7-acre site.

North Avenue to be widened from Somerset Terrace to Moreland Avenue.

F-056 Freeway—general alignment

Frontage roads to be constructed between Euclid Avenue and Highland Avenue on sides of F-056 Freeway.

Clearance of blighted area would permit conversion to multi-family development.

Highland Avenue to be widened from Boulevard to Ponce de Leon Avenue.

Moreland Avenue to be widened from McLendon Avenue north to St. Charles Place.

SCALE I
2400
3200

MENT
TY
ND HIGH DENSITIES
PUBLIC SPACE
AL

TITUTIONAL

NTERS
ONS

EET SYSTEM
TRANSIT

3200

Free-
align-

e Avenue to
ended from
e Avenue to
d Avenue.

The era of building highways to speed suburbanites to and from downtown was in full swing. In 1964, the Georgia Highway Department (GHD) proposed a new highway (I-485) from the downtown connector to I-85 near Lindbergh Drive. I-485 was presented as a 6.27-mile, limited-access highway with 8–10 lanes and speeds of 50–60 miles per hour. Initially, four different routes were considered; a fifth was soon added. The roads would have crossed the Old Fourth Ward and the Atlanta neighborhoods of Bedford Pine, Virginia-Highland, Morningside-Lenox Park, and Lindridge/Martin Manor. The Federal Highway Administration approved the concept in October 1964 and authorized the GHD to prepare preliminary plans. This insane 1970 version shows I-485 bisecting Orme Park, a cloverleaf at Virginia Avenue, and (as an extra bonus) an extended 14th Street slicing Piedmont Park in half on the way to Monroe Drive. (Courtesy of Joseph Drolet, Department of Planning, Atlanta.)

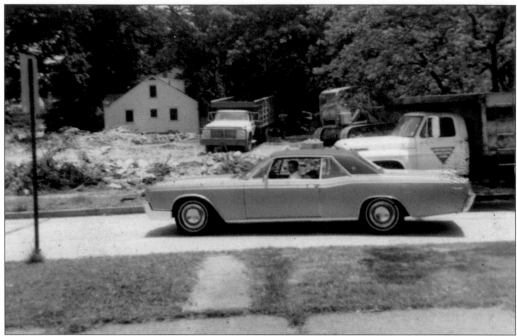

The Georgia Highway Department began condemning land and razing houses along Virginia Avenue, whose addresses are now on the granite columns in John Howell Park. Neighbors watched in shock as bulldozers leveled the 1920s bungalows. Residents immediately north of Amsterdam Avenue incorporated the Morningside-Lenox Park Association (MLPA) in May 1965 to fight the highway. They filed suit in Fulton Superior Court in May 1966; the suit was denied the following June, as was its appeal. The highway appeared inevitable and MLPA changed its strategy to negotiating design changes in the route and reducing the highway's impact. (Above, courtesy of Susan Kraham; below, courtesy of Dani Miller.)

A new wave of bold female leaders—the so-called blue jean elite—took leadership in MLPA. At right, Mary Davis stands in front of a dilapidated house at the corner of Virginia Avenue and Greencove Avenue. Davis and her friends Virginia Gaddis (below), Adele Northrup, Barbara Ray, and Virginia Taylor dubbed themselves the "City Mice" and went door-to-door to raise money and collect petition signatures. Northrup had moved intown specifically for its walkability. The specter of the highway prompted many older residents to sell but made banks reluctant to loan. Many houses were divided into inexpensive apartments, whose new occupants were often younger and active in Atlanta's burgeoning antiwar and counterculture movements. (Right, courtesy of Mary Davis; below, courtesy of Adele Northrop.)

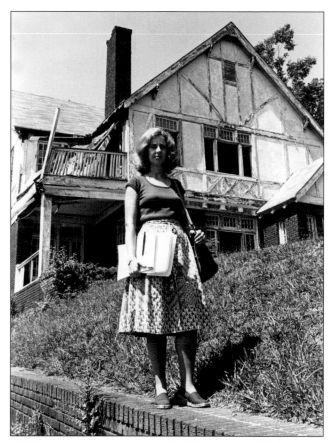

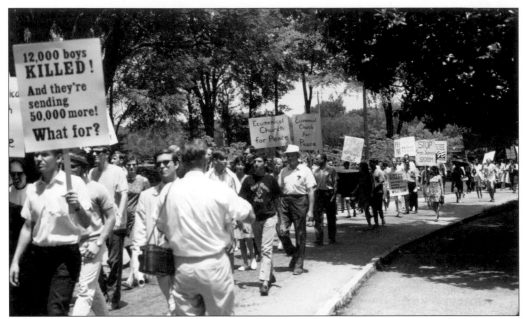

"The Strip," at the corner of 10th Street and Peachtree Road, became the official media locus of the counterculture. Nearby Piedmont Park (shown above) was a popular destination for demonstrations and musical gatherings. The Allman Brothers and the Grateful Dead played there a number of times—always for free. In 1942, the war department purchased the old Ford Motor Company Assembly Plant (below) on Ponce de Leon Avenue. A regional draft induction center in the 1960s, it was a focus of opposition to both the war and the draft. Today, retail shops and apartments occupy the building. (Above, courtesy of Kenan Research Center at the Atlanta History Center; below, courtesy of Robin Davis.)

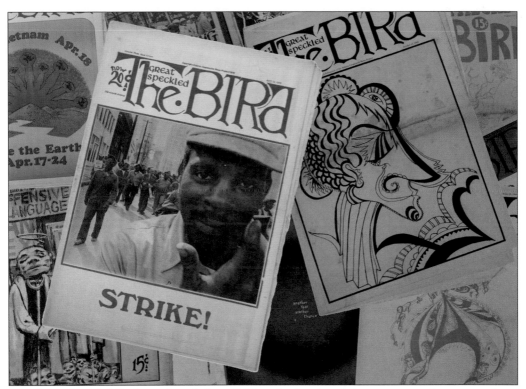

The Great Speckled Bird was founded in 1968 at the height of the antiwar and counterculture movements. Its radicalism was a blunt rejection of traditional two-party, lesser-evil politics; the lead story of the first issue, "What's it All About, Ralphie?," pans longtime *Atlanta Constitution* editor and liberal icon Ralph McGill. Characterized as an underground paper and widely sold by street vendors, the *Bird*, with a circulation of over 20,000 copies, was the third-largest weekly paper in the state by 1970. The paper covered the antiwar, civil rights, labor, women's, and gay movements. Much of the *Bird*'s staff lived in and around Virginia-Highland, including Tom and Stephanie Coffin, Steve Wise, Ann Taylor Boutwell, Nan Orrock, Diamond Lil, Anne and Howard Romaine, Becky Hamilton, and Gene Guerrero. (Both, courtesy of Tom Coffin and Jack White.)

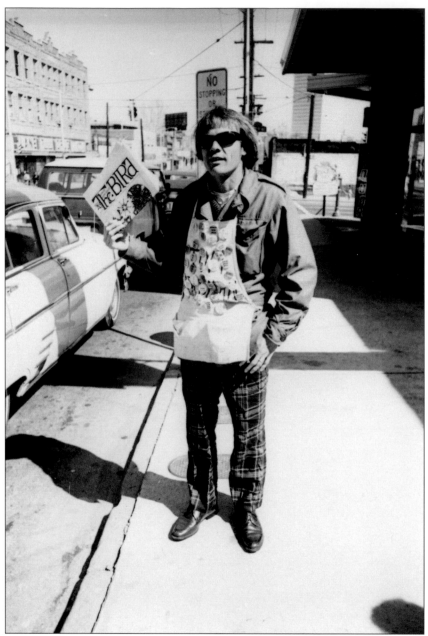

The *Bird*'s blunt critiques of local politicians gave it outsized influence. The conduct of the Atlanta Police Department (overwhelmingly white in a predominantly black city), DeKalb County's glacial pace of school integration, and the low wages of city workers were frequent targets, along with Atlanta mayor Sam Massell. The firebombing of the *Bird*'s office off Piedmont Road—and the tepid investigation of the crime, which was never solved—angered many supporters of the paper. Massell's 1973 reelection campaign against Maynard Jackson was widely seen as a clash between the status quo and new approaches to community problems. Massell's runoff slogan—"Atlanta's Too Young to Die"—and television advertisements showing debris blowing across a vacant street (in Philadelphia!) drew the *Bird*'s immediate condemnation. The advertisement remains one of the most infamous in Atlanta political history. (Courtesy of Tom and Stephanie Coffin.)

Three

FIGHT FOR SURVIVAL

BUILDING NEIGHBORHOOD INFRASTRUCTURE

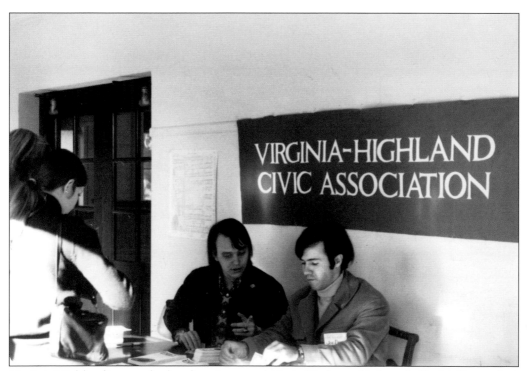

Virginia-Highland's central urban location, proximity to Piedmont Park, and affordability made it an attractive destination for young adults all over the South. Many new citizens lent their voices to the growing highway battle. In the process, they strengthened the local civic associations, some of which had become inactive. (Courtesy of Joseph Drolet.)

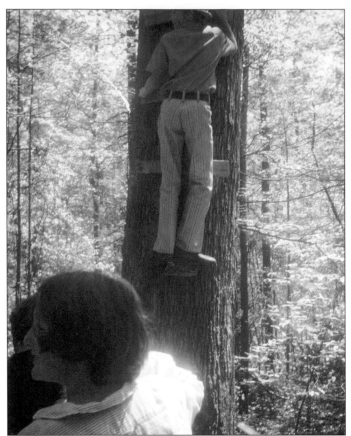

I-485's final proposed route abutted Inman Elementary and crossed Orme Park, triggering the National Environmental Policy Act's requirement for an environmental impact study. MLPA filed suit again in 1971, asking the federal court to require the highway department to submit such a study. The court agreed. The concept of environmental impacts seemed to befuddle the highway department, which struggled mightily—and unsuccessfully—to comply; this was a pattern it would repeat a decade later in the battle over the Stone Mountain Freeway. The process ground to a halt, encouraging opponents and giving the opposition time to develop. (Both, courtesy of Adele Northrup.)

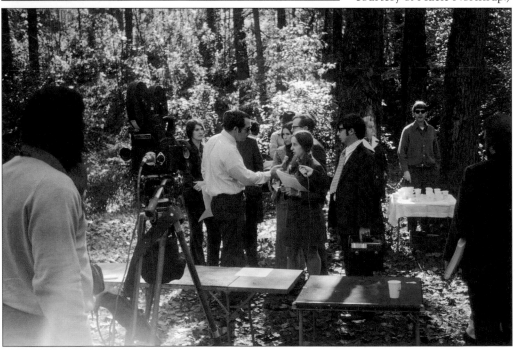

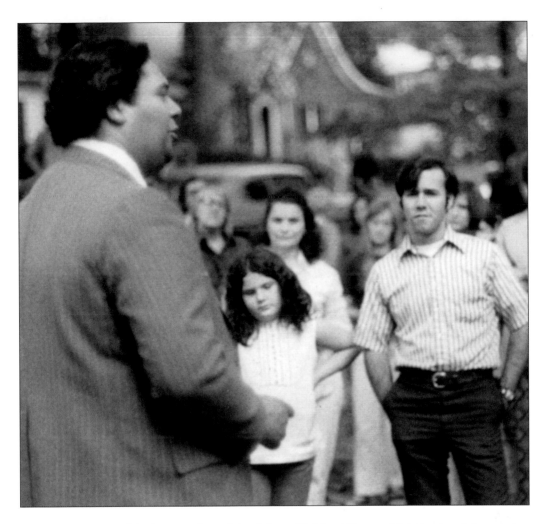

Citing the opinion of the last president of the defunct Highland-Virginia Neighborhood Association (HVNA)—which had not met for years—the Georgia Highway Department had repeatedly claimed that community residents were in favor of the proposed highway. In the fall of 1971, new Atlanta resident Joseph Drolet (an assistant district attorney for Fulton County) challenged this assertion by walking the community and asking neighbors to post signs and bumper stickers opposing the highway. Drolet received a warm response; he and his colleagues decided to form a new neighborhood association with a new name. (Above, courtesy of Mary Davis; below, courtesy of Joseph Drolet and Mary Davis.)

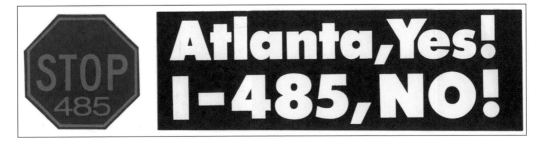

State of Georgia

OFFICE OF SECRETARY OF STATE

I, Ben W. Fortson, Jr, Secretary of State of the State of Georgia, do hereby certify, that

based on a diligent search of the records on file in this office, I find that the name of the following proposed domestic corporation to wit

"VIRGINIA-HIGHLAND CIVIC ASSOCIATION, INC."

is not identical with or confusingly similar to the name of any other existing domestic or domesticated or foreign corporation registered in the records on file in this office or to the name of any other proposed domestic or domesticated, or foreign corporation as shown by a certificate of the Secretary of State heretofore issued and presently effective.

This certificate is in full force and effective for a period of 4 calendar months from date of issuance. After such period of time, this certificate is void.

IN TESTIMONY WHEREOF, I have hereunto set my hand and affixed the seal of office, at the Capitol, in the City of Atlanta, this 22nd day of August, in the year of our Lord One Thousand Nine Hundred and Seventy Two and of the Independence of the United States of America the One Hundred and Ninety-seventh

Secretary of State, Ex-Officio Corporation Commissioner of the State of Georgia

167

"Highland-Virginia" reflected both Highland Avenue's and Virginia Avenue's historic status as the neighborhood's primary routes. Inverting the names of the previous association offered an easy answer to the challenge of creating a new name. Defining neighborhood boundaries could have been contentious, but Drolet and Mary Davis, from Morningside, negotiated those easily. Amsterdam Avenue was the logical dividing line on the north, as was Ponce de Leon Avenue on the south; the railroad (now the BeltLine) on the west and the city limits on the east (predominantly Briarcliff Road) were logical. In August 1972, Drolet registered the Virginia-Highland Civic Association (VHCA) with the secretary of state, and the name of the community known today was born. (Courtesy of Joseph Drolet and VHCA.)

The Virginia-Highland Tour of Homes was first held in December 1972 to bolster community spirits, display the community's renovated homes, and raise funds. The first tour featured 13 homes and drew 1,000 attendees, each making a $1 donation. Held intermittently for several decades, the Virginia-Highland Tour of Homes has been an annual event since 2004. Originally valued for showcasing innovative renovations, its potential as a neighborhood fundraiser became apparent in 2011 under the direction of Ann Guy and Mandi Robertson, when it earned almost $20,000. Subsequent tours led by Angelica Taylor and Robin Ragland expanded sponsorships and sharply increased revenues. The 2016 tour sold 1,900 tickets and netted almost $60,000. (Both, courtesy of VHCA.)

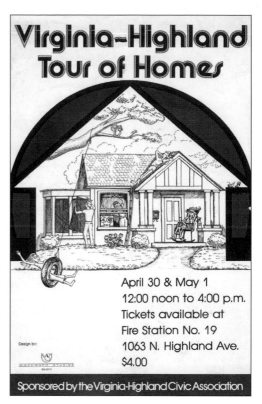

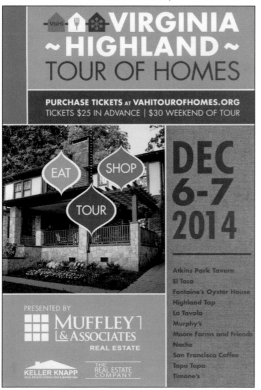

THE VIRGINIA-HIGHLAND VOICE

NEWSLETTER OF THE VIRGINIA-HIGHLAND CIVIC ASSOCIATION · P.O. BOX 8041, STATION F · ATLANTA, GA. 30306

AUGUST 1, 1972

Candidates To Speak at Meeting

The four Democratic candidates for the 5th District Congressional seat will appear before a meeting of the Virginia-Highland Civic Association on August 6, 1972. The candidates are Wyche Fowler, Henry Dodson, Andrew Young and Howell Smith.

The meeting, which is open to the public, will be held at Inman School on Virginia Avenue and will begin at 8:00 P.M.

The candidates will be asked questions prepared by the Steering Committee of the Association and will then respond to questions from the floor.

The regular meeting of the Association will be held following the presentation of the candidates.

TOUR OF HOMES PLANNED

The Association is planning a Tour of Homes to be held during the month of September. The Virginia-Highland area has many older homes that have been beautifully restored. A number of homeowners have made major structural changes in their homes with impressive results.

The tour is in the planning stage and anyone interested in being on the Tour Committee should contact a member of the Steering Committee.

Other activities, such as a flea market, garage sale and area picnic may also be held in conjunction with the Tour.

MEMBERSHIP DRIVE IN PROGRESS

The Association is presently engaged in a complete canvassing of the area. The purpose of the canvassing is threefold. First, the canvassing will provide complete and accurate statistics on the population of the area. Second, the canvassing will help to spread general information about what is happening in the area. Lastly, the canvass provides an opportunity for area residents to join the Association.

The canvassing is being conducted using 5 by 8 inch information cards. Everyone contacted is asked to fill-out a card even though they may not wish to participate in neighborhood activities. If they do wish to join the Association there is a space provided on the card to indicate this.

City plans call for a 22 foot widening of Monroe Dr. and Highland Ave.

NEIGHBORHOOD ORGANIZES

The Virginia-Highland Civic Association was recently formed to face area problems such as the expressway, proposed street widenings and the constant pressure for zoning changes.

The boundaries of the Association have been set as: Amsterdam Ave. on the north, Briarcliff Rd on the east, Ponce De Leon Ave. on the south and Monroe Drive and the Southern Railway (along Piedmont Park) on the west.

The present members of the Steering Committee are:

Joe Drolet,
 Phone 875-3702
Sybil McWilliams,
 Phone 872-4407
Joyce Webb,
 Phone 874-9490
Bob Dinwiddie,
 Phone 876-0896

Dues for the Association are ten dollars per year (dues can be waived for anyone who cannot afford the ten dollar amount). Anyone wishing to join the Association can do so by sending dues to:

Virginia-Highland
Civic Association
P.O. Box 8041
Station F
Atlanta, Ga. 30306

Mary Drolet designed the original VHCA logo (shown below) to symbolize a new day dawning in the community. The first VHCA newsletter was published in August 1972 and explains the new association and the fight against the highway. A small group walked the streets to hand out newsletters, which generated excellent attendance at the first meetings. Inman school (below) hosted VHCA meetings and the Virginia-Highland Tour of Homes. While the legal battles raged, both VHCA and MLPA pressured local politicians to oppose the highway. In June 1973, the Atlanta Board of Aldermen overwhelmingly expressed its opposition, voting 15–2 against the road; the proclamation was signed that evening at Manuel's Tavern by then mayor Sam Massell. (Both, courtesy of Joseph Drolet and VHCA.)

MAYNARD, YES!
I-485, NO!

In the fall of 1973, Maynard Jackson assembled a coalition of black and intown voters and became the first African American elected to a citywide office. He had campaigned opposing I-485, and his election signaled continued problems for the highway department. The next year, the federal government rejected the highway department's new environmental impact study on four different grounds. (Courtesy of Joseph Drolet.)

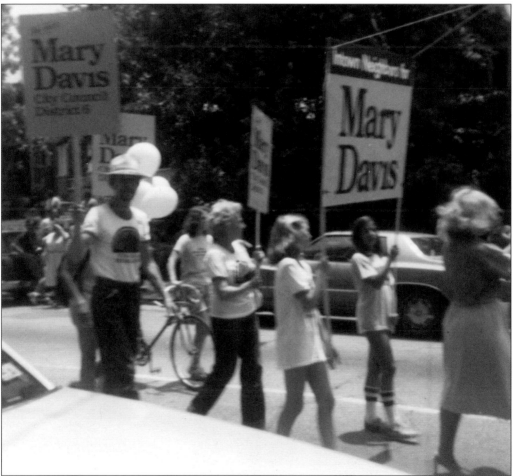

The bitter battle ended with a whimper, not a bang. In 1975, the highway department quietly removed I-485 from its list of federal funding requests, ending the 10-year fight. Over 900 parcels had been acquired and many homes had been demolished, but the neighborhood had survived. Residents schooled in the lessons of the war, Watergate, and I-485 were optimistic about their ability to make changes. Some, including Mary Davis (pictured at right), would soon be in city government. (Courtesy of Judy Beasley.)

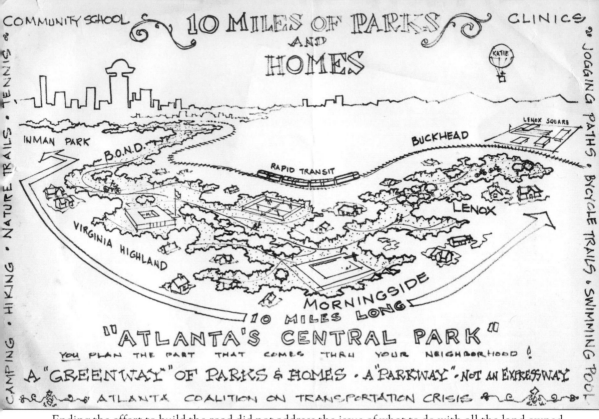

COMMUNITY SCHOOL • TENNIS & NATURE TRAILS • HIKING • CAMPING

10 MILES OF PARKS AND **HOMES**

CLINICS • JOGGING PATHS • BICYCLE TRAILS • SWIMMING POOL

KATIE

INMAN PARK

B.O.N.D.

RAPID TRANSIT

BUCKHEAD

LENOX SQUARE

LENOX

VIRGINIA HIGHLAND

MORNINGSIDE

10 MILES LONG

"ATLANTA'S CENTRAL PARK"

YOU PLAN THE PART THAT COMES THRU YOUR NEIGHBORHOOD!

A "GREENWAY" OF PARKS & HOMES • A "PARKWAY" NOT AN EXPRESSWAY

ATLANTA COALITION ON TRANSPORTATION CRISIS

Ending the effort to build the road did not address the issue of what to do with all the land owned by the Georgia Highway Department. The Maynard Jackson administration offered an ambitious "Great Parks" concept that foreshadowed the BeltLine in its vision of diverse neighborhoods linked by parks, trails, and recreational facilities. The highway department, smarting from the road defeat and Jackson's role in it, scorned the idea. Most of the land was eventually offered back to the original owners or sold at auctions. After extensive effort, neighbors were eventually able to create new parks on former road land in Virginia-Highland (John Howell Park) and in Morningside (Sidney-Marcus Park). (Courtesy of Adele Northrup and ACTC.)

Four

AT A CROSSROADS
NEW URBAN PIONEERS

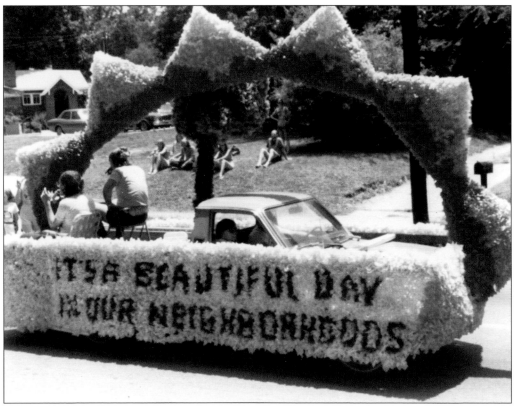

A vibrant mix of residents had won a huge public battle. When the celebrations ended, the view was sobering. The landscape was littered with empty lots, some citizens had fled, and code enforcement issues were endemic. But the city's first African American mayor—the optimistic and community-minded Maynard Jackson—was in office and citizen confidence was high. (Courtesy of Few Hembree.)

APPLE Corps, Inc.

SCHOOL TALK

Atlanta Parents and Public Linked for Education

| Volume I, Number 3 | January, 1980 |

Public School Supporters-- a Look at Our Heritage:

New year, new decade-- a good time to look at the past record of our public schools and our involvement in them; to take stock of the present; and to make wishes and workplans for the future.

APPLE Corps began in May 1979, a child of eleven parents, whose organizations you may read about here, and heir of other groups as well, from the recent past. We briefly present here a history of the citizen groups concerned with public education in the seventies (leaving out the APPLE Corps Board groups). We will surely leave out some contributors--we count on our readers to set us straight.

The NAACP, with the School Board, attracted citizen participation from all over with city as they worked out details of the Compromise Plan for desegregation, in 1970. For many, this was the first focus on a city-wide issue.

In Southwest Atlanta in the early seventies, the "Advocates" formed, to analyze needs of the new black community in Southwest Atlanta, and sponsor forums and task forces.

In 1973, Randy Taylor's "Ad Hoc Committee" pushed the Superintendent to make good rather than haphazard plans for desegregation. The Ad Hoc Committee met for almost 2 years, ending in the early days of the Compromise Plan.

Civic associations, NPUs and AHA tenants associations have focussed on schools; some have become active forces in their neighborhood schools ⧓ ⧓

.

In this issue of SCHOOLTALK, six of the eleven APPLE Corps board groups introduce themselves: their goals, accomplishments and particular interests in Atlanta's public schools. The six are: Atlanta Chamber of Commerce, Atlanta Council for Public Education, Council for In-Town Neighborhoods and Schools, Northside Atlanta Parents for Public Schools, Atlanta Junior League, and Parents for Action.
February's SCHOOLTALK will present the five remaining organizations.

By the early 1970s, the impacts of Atlanta Public Schools' (APS) full integration were plain to see. Local enrollments fell sharply as the baby boomers were replaced by younger adults. Uncomfortable about their children attending now predominantly black schools, some white families chose to attend newly formed private schools. Organized parental responses included the creation of Apple Corps and the Council of Intown Neighborhoods and Schools (CINS) in 1977. Both were public education advocacy groups that argued for the viability and quality of public education and promoted the exchange of best practices in local schools. Among the initial activists were Nancy Hamilton and Joe Martin; Martin later became the area's school board representative. (Above, courtesy of Nancy Hamilton; left, courtesy of Apple Corps, Inc.)

During the 1973 race, Maynard Jackson promised citizens a greater voice in city government. His planning director, Leon Eplan, created neighborhood planning units, or NPUs, to serve as a communication and policy system between the city and its residents. Originally quite powerful (briefly with the power to disapprove liquor licenses and some permits), the NPUs subsequently evolved into an advisory board. Hamstrung by an absence of funding and planning expertise, the system still provides a formal venue to approach zoning and planning issues. NPU-F was the forum in which Virginia-Highland formally demonstrated the depth of support for neighborhood commercial zoning in 2008 and for its master plan in 2014. In 2006, the overwhelming local opposition to the Atlanta Botanical Garden's placement of its parking deck in the middle of Piedmont Park spilled into the hallways. (Right, courtesy of Few Hembree; below, courtesy of Lola Carlisle.)

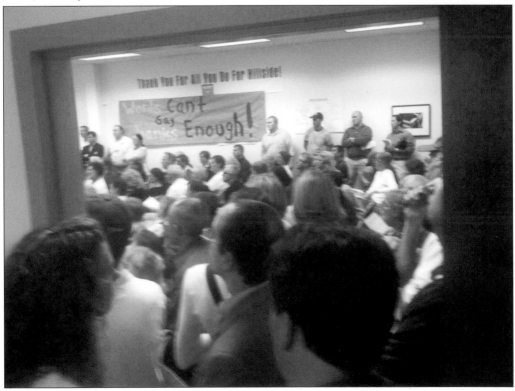

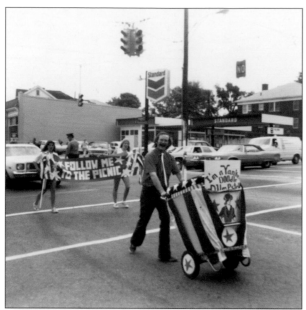

The Jackson administration changed the city's trash pickup from a twice-a-week backyard system to weekly curbside system using large plastic containers known as "Herbie Curbies," which could be emptied mechanically. The animal-proof containers greatly reduced trash on the ground, and the rear alleys previously full of rusty garbage cans became de facto additions to adjoining lots. Virginia-Highland residents promptly created a "Herbies on Parade" competition as part of the Fourth of July activities. (Courtesy of Few Hembree.)

The Fourth of July festivities soon included a "Miss Tastefully Tacky Virginia-Highland Pageant" at Walter Mitty's, a bar at the site of today's Dark Horse Tavern. The lucky winner received a cardboard crown and a 20-pound bag of Vidalia onions. Ann Taylor Boutwell, a Miss Tastefully Tacky contender, and her unidentified friend pose for the camera. (Courtesy of Few Hembree.)

Opposition to the highway included a 1972 pig roast amidst the highway department's "No Trespass" signs on the I-485 lots along Virginia Avenue. The event attracted political candidates and media and was so popular that it outlived the defeat of the highway. In 1977, the event drew more than 4,000 people and featured a parade, ringmaster, floats, bands, bagpipes, and representatives from the Fulton County Sheriff's Office. (Courtesy of Judy Beasley.)

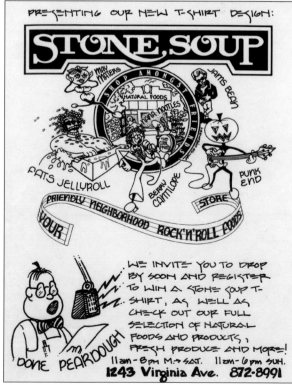

The Stone Soup Co-op was an early example of the coming decades' quest for healthier food at lower prices; its first newsletter was created in December 1971. At the co-op's peak, its 500 members operated from a storefront at 996 Virginia Avenue and bought in bulk directly from vendors at the State Farmers Market in Forest Park. Their popular cookbook was widely used; white rice is nowhere to be found. (Courtesy of Stone Soup Cooperative Association.)

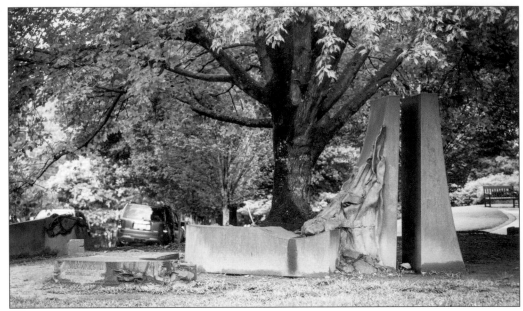

Virginia-Highland's casual atmosphere and affordable housing made it attractive to many artists. John McWilliams (later a professor at Georgia State University) was a founder of Nexus, the city's first photography gallery, at the corner of Virginia Avenue and Rosedale Drive. In 1977, George Beasley, also a professor at Georgia State University, won a VHCA–sponsored art contest with his *Bulwarks II*, which was permanently installed at the median at Virginia Avenue and Lanier Boulevard after an exhibit at the High Museum. Beasley and McWilliams were members of the Atlanta Art Workers Collective, whose newsletter spawned the highly influential *Art Papers*. At least a half dozen studios occupied retail spaces in Virginia-Highland between 1975 and 1985; holiday sales offering fine art, jewelry, photography, pottery, and blown glass were a regular feature of the period. (Above, courtesy of Nic Huey; below, courtesy of Judy Beasley.)

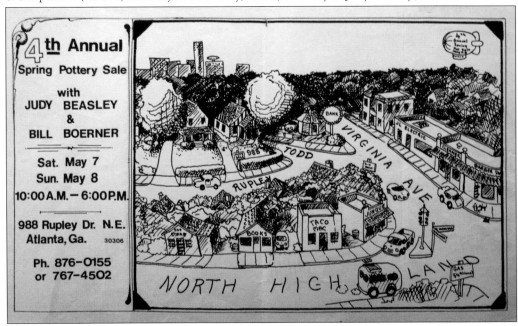

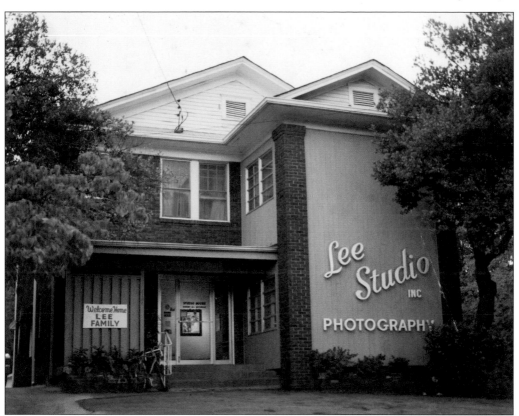

Helen and Jim Lee moved from Berkeley, California, in 1951 and opened a photography studio at 1001 Highland Avenue (above). For 35 years, they photographed weddings, parties, bar and bat mitzvahs, and notable citizens of the community, including Diamond Lil, the legendary Atlanta drag queen (right), who resided at Bonaventure and Greenwood Avenues. Diamond Lil moved to Virginia-Highland in 1965, when cross-dressing was illegal. Lil covered the struggle of the gay and counterculture community in the *Great Speckled Bird* and was a pioneer in the LGBTQQ movement in the region. (Above, courtesy of Helen Lee; right, courtesy of Kiki Carr and Diamond Lil.)

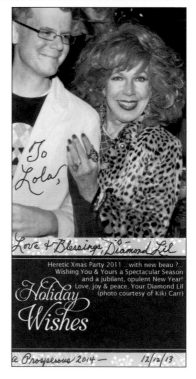

To Lola,

Love & Blessings, Diamond Lil

Heretic Xmas Party 2011 .. with new beau ?..
Wishing You & Yours a Spectacular Season
and a jubilant, opulent New Year!
Love, joy & peace, Your Diamond Lil
(photo courtesy of Kiki Carr)

Holiday Wishes

& Prosperous 2014 — 12/12/13

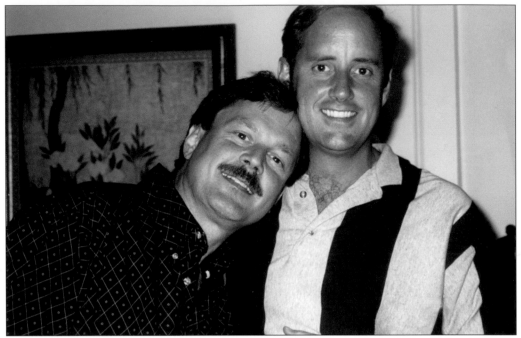

Virginia-Highland gradually became a community in which many gay citizens felt comfortable living openly. In 1985, Rob Lamy (right) and Jim Hipkens settled on Virginia Circle, where for decades they quietly enjoyed their home and neighbors and tended an extraordinary garden. Though they had been a couple for 40 years and married in New York, Hipkens's original 2014 Georgia death certificate read "Partner"; Rob had it amended to "Spouse." (Courtesy of Rob Lamy.)

The Virginia Avenue Baptist Church, founded in 1923, built its new sanctuary across from Inman school in 1950. The Southern Baptist Convention's hostility to the ordination of women and the reluctance to embrace openly gay and bisexual congregants spurred the congregation to drop its affiliation in 1999. The renamed Virginia-Highland Church has embraced social responsibility and grown steadily ever since. (Courtesy of Dani Miller.)

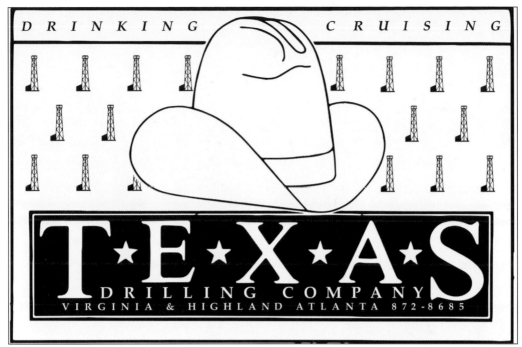

One of the first gay bars that catered to the "leather-levi" crowd was Texas Drilling Company, at the corner of Virginia and Highland Avenues. While the neighborhood was an increasingly safe place to be openly gay, some patrons recall being challenged while returning to parked cars in the late evening. Texas Drilling Company closed in 1985. (Courtesy of Texas Drilling Company.)

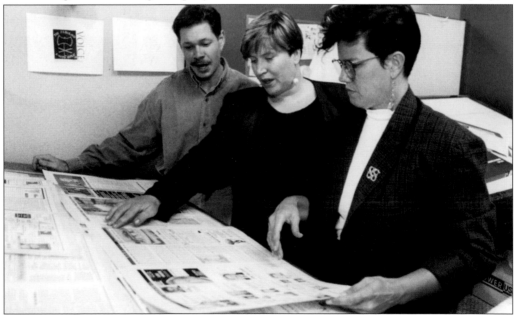

Southern Voice—commonly known as *SoVo*—was founded in 1988 to focus on local and regional LGBTQQ political issues. Its early offices were in Virginia-Highland. A bullet hole on display for years in the office window at 1183 Virginia Avenue was a grim reminder of the staff's courage and the paper's effectiveness. This photograph features some of the staff in 1992. (Courtesy of AP/AJC.)

Mary Alyce Ware, born in 1930, lived a full life marked by many of the challenges that the women of her generation faced. Recovering from polio, she could not climb the stairs and lost a year at Inman school. She later watched her mother suffer emotionally from the death of a friend who did not survive a backroom abortion. Mary Alyce graduated from Sophie Newcomb College in 1953 and became an auditor at the Life of Georgia Insurance Company—sans the title, which was offered only to men at that time. In 1969, she purchased the home next to her parents on North Virginia Avenue; her ample salary and savings notwithstanding, the loaning bank required her father's signature as well. In 1972, emboldened by Congress's sending the Equal Rights Amendment (ERA) to the states for ratification, she demanded and received the full job title and accompanying benefits from her employer. Ironically, the ERA fell short of passage by three states; Tennessee and Texas were the only southern states to support it. (Courtesy of Mary Alyce Ware.)

Virginia-Highland
The Best Living Intown

A new generation of residents was soon looking for both childcare and organized early education, especially as the number of working mothers increased. Babysitting co-ops were a start; Mother's Day Out and daycare programs, frequently operating in churches, soon followed. Morningside MDO (at Morningside Presbyterian), Druid Hills Presbyterian Preschool, Druid Hills United Methodist Preschool (below), Haygood UMC Preschool, Congregation Shearith Israel Hebrew Academy Preschool, Kids Kondo, and Canterbury School flourished in the community for many years. Many of the personal relationships among children and parents in these settings lasted for decades. (Above, courtesy of VHCA; below, courtesy of Lola Carlisle.)

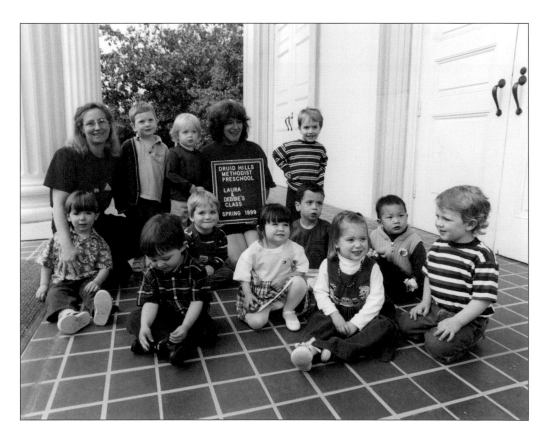

The counterculture adoption of Piedmont Park initiated an era of popularity there that continues to this day. The waves of young people who had first come for music and politics later returned with their children for recreation and organized sports. Maynard Jackson closed the park's golf course in the late 1970s; the old fairways along 10th Street were instantly filled with picnickers and Frisbees. Jackson also closed the park's through roads, creating a safe haven for cyclists, strollers, and skateboarders. In the late 1970s, the first American soccer boom arrived. The number of players grew in proportion to the surrounding neighborhoods; by the mid-1980s, the game was being practiced and played seven days a week in spring and fall. A generation of intown children and adults treasured practicing and playing on the worn fields at Piedmont Park, a halcyon era that ended when the Piedmont Park Conservancy took over and carefully regulated field usage. (Courtesy of Judy Beasley.)

The Briarcliff Terrace Apartments were built in the 1950s between Rosedale Drive and Briarcliff Place. Affordable and convenient, the units were popular with Cuban refugees in the 1960s and other Latino residents over the decades. Language and class barriers and limited road access—one road on the south, one on the north—have limited interaction with neighbors. The value of the land makes the future of this diverse community very uncertain. (Courtesy of Nic Huey.)

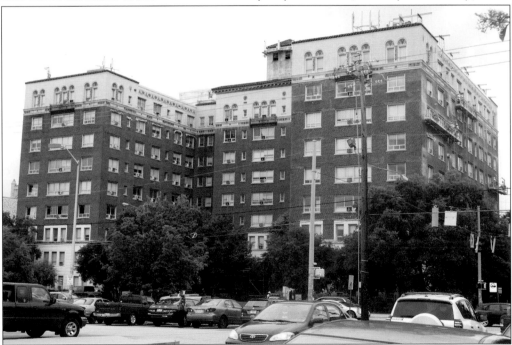

The Briarcliff Summit, at Ponce and Highland Avenue, has been the home of senior and disabled citizens since 1980. Built as the Briarcliff Hotel in 1925 by Coca-Cola magnate Asa G. Candler Jr. and listed in the National Register of Historic Places, the structure was an exclusive apartment building before suffering years of neglect. Carefully renovated in 2015, it now contains 200 apartments. (Courtesy of John Becker.)

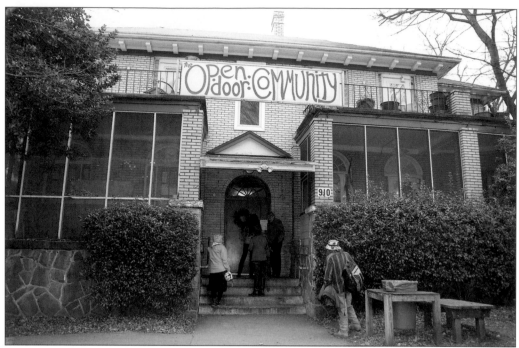

In 1980, Ed Loring and Murphy Davis converted an apartment building owned by the Greater Atlanta Presbytery (above), on Ponce de Leon, into the Open Door, a residential Christian community serving marginalized citizens, especially the homeless. At its peak, Open Door provided 10,000–12,000 meals each month, along with showers, medical clinics, and a foot clinic. Loring and Davis raised their daughter there; many remarkable staff members served long tenures before the facility's closing in January 2017. Their clients were identified and celebrated in photographs in the hallway (below). They included Paul (his last name is withheld by request), whose longtime residence on a bench on Highland Avenue has been a lightning rod for homelessness and has invoked a complicated mix of sympathy, anger, and tolerance from business owner and residents. (Both, courtesy of John Becker.)

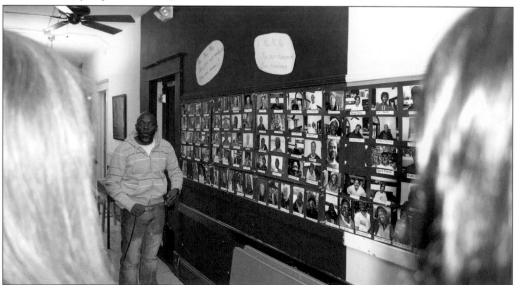

I-485 was defeated, but empty lots and the foundations of demolished homes remained along Virginia Avenue. Years of discussions with the state and city eventually produced an agreement to build a park. The section of De Leon Street that originally extended to Virginia Avenue was closed. Homes that the Georgia Highway Department had removed on the south side of Virginia Avenue were memorialized with small plaques bearing their original addresses on the granite columns that lined the park. (Courtesy of Robin Davis.)

The park was named after John Howell, a gay rights activist and president of VHCA who died in 1988 from HIV complications. The park became the first in the country with an HIV component. The project was managed and overseen by Virginia-Highland residents Jerry Bright (far right) and Rick Porter (far left), pictured here with Congressman John Lewis and Mary Davis. Peter Frawley was the landscape architect. (Courtesy of Jerry Bright.)

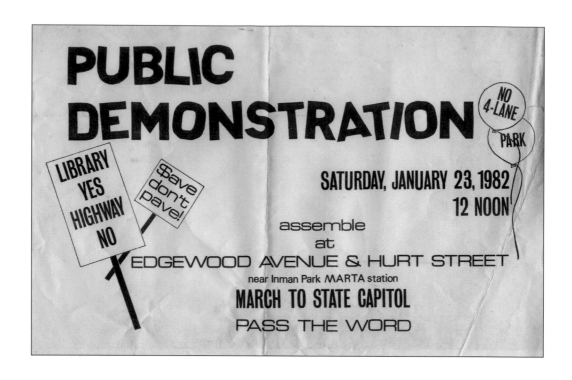

PUBLIC DEMONSTRATION

NO 4-LANE PARK

LIBRARY YES HIGHWAY NO

Save don't pave!

SATURDAY, JANUARY 23, 1982
12 NOON

assemble
at
EDGEWOOD AVENUE & HURT STREET
near Inman Park MARTA station
MARCH TO STATE CAPITOL

PASS THE WORD

The highway department never gave up on building an eastern leg of I-485 from downtown to the Stone Mountain Freeway. The 1980 presidential defeat of Jimmy Carter provided an ironic pretext: the need for a highway that would go by (and far past) his new presidential library off Highland Avenue. Leading the effort was Carter's former United Nations ambassador, newly elected Atlanta mayor Andrew Young, who ran for office opposing the four-lane, limited-access highway but then supported a four-lane, limited-access parkway. The extraordinarily bitter Presidential Parkway battle featured citizens climbing trees to halt construction, courageous judicial work by DeKalb Superior Court judge Clarence Seeliger, tie votes in city council, accusations of bribery, construction lawsuits, and more rejected environmental impact statements from the renamed Georgia Department of Transportation. Many houses were lost in the process, but the only new road built ended at Ponce de Leon. (Both, courtesy of Mary Davis.)

BUILD IT IN PLAINS

THE AMERICAN MUSIC SHOW Cable Atlanta Channel 16 Mon/ Wed 10pm Box 54472 Atlanta 30308

Five

BACK IN BUSINESS

FULL SPEED AHEAD

By the mid-1980s, Virginia-Highland was a funky, artistic community that provided opportunities for smart commercial investment. A new wave of businesses offered a variety of goods and services, and the area had become a destination for the arts, unique food, and energetic nightlife. (Courtesy of David Hoffman and Jan Silverstein.)

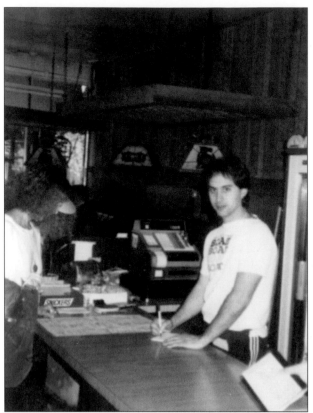

In 1961, George Najour opened George's Deli and Bar, at 1041 North Highland Avenue. The front section featured a Middle Eastern deli, where they sold groceries and sandwiches that drew customers from the local Greek, Jewish, and Middle Eastern communities, with the bar in back. Today, his son G.G. (left) and grandson George run the business. (Courtesy of G.G. Najour.)

For 54 years, Dr. Marvin Kaplan ran a highly successful dentistry practice from his small office building at the corner of Virginia and North Highland Avenues (his family is shown below). Born and raised in Atlanta, Kaplan was a graduate of Boys High and Emory University and served in the public health service, where he was a strong advocate of fluoridation. He practiced until three weeks before his death in 2009 at age 85. (Courtesy of Barbara Kaplan.)

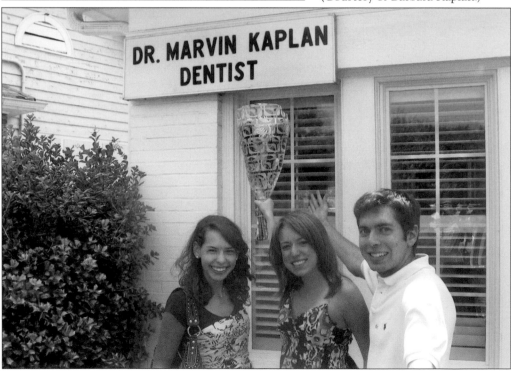

Doug Eifrid opened Intown Hardware—later Intown Ace—in 1981 and built the current store at Drewry Street and Highland Avenue in 1984. His timing was perfect; the neighborhood's old homes were being renovated at a record pace. Intown has been the personification of a friendly community hardware store for three decades; Doug's son Micah now operates the business. In 2015, local artist Stephanie Coffin installed a colorful horticultural mosaic on the store's corner planter. (Courtesy of Dani Miller.)

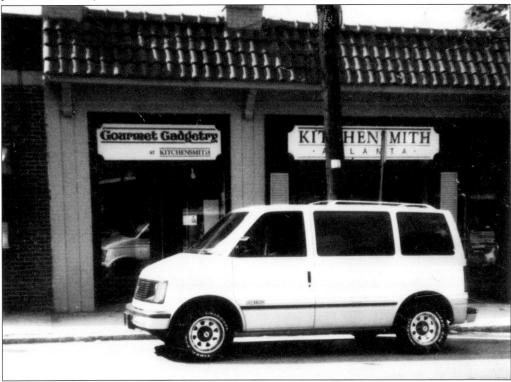

In 1983, Herb Schmidt's furniture business in Virginia-Highland evolved into Kitchensmith, at 1198 North Highland Avenue. Showroom kitchens where architects could meet with customers were an early sign of the growing demand for upscale renovations. He also featured a gourmet gadgetry shop. The business did quite well and eventually moved to Buckhead. (Courtesy of Herb Schmidt.)

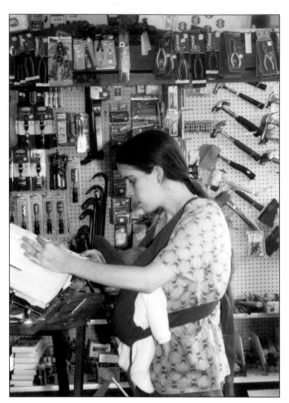

In 1978, Chris and Sharon Bagby opened Highland Hardware (now Highland Woodworking) at 1034 North Highland Avenue. They later bought the building and adjacent lot at 1045 and moved across the street. Originally a classic nuts-and-bolts hardware store, the business has specialized in woodworking tools for years. Locally and nationally famous woodworkers have taught classes on-site. Today, much of their business is mail order. (Courtesy of Sharon Bagby and Chris Bagby.)

The Bagbys paved the parking lot at North Highland and Los Angeles Avenues in the early 1970s. The parking spaces have special value today. They serve Highland Woodworking during the day and other businesses in the evening that need them to meet their neighborhood commercial zoning requirements. This image shows the lot buried in snow in the 1970s. (Courtesy of Shirley Hollberg.)

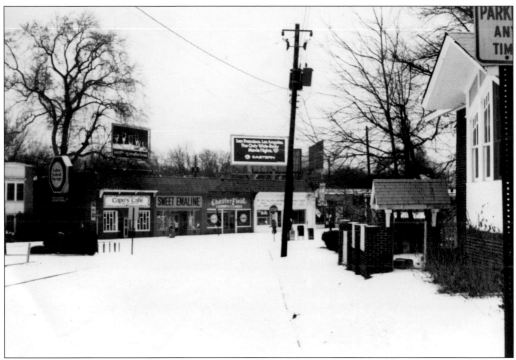

John and Linda Cappozzoli opened Capo's Café (seen in photograph) at 992 Virginia Avenue. It was the first successful new restaurant of the 1970s. Long lines gave the corner a much-needed buzz; their treasured Chicken Diablo recipe is still passed around. John was an early advocate of the area. (Courtesy of Zoe Lancaster.)

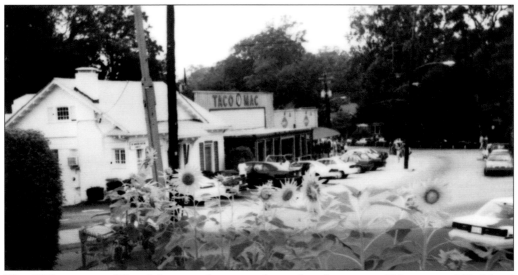

The 1979 opening of Taco Mac was a huge step forward at the corner of Virginia and Highland Avenues. Its hundreds of foreign beers and hot chicken wings were then a new approach; the multiple televisions tuned to sports were also unique. It was the franchise's first location; by 2012, there were 28 Taco Macs in three states. (Courtesy of Rufus Stansell.)

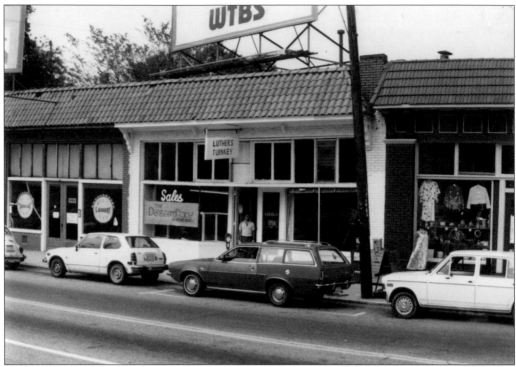

In 1979, Sheryl Meddin and Bennett Frisch took a chance on a new concept—a restaurant that only served dessert. They chose Virginia-Highland for its reasonably priced real estate and up-and-coming vibe; their intuition and hard work paid off. The Dessert Place was a huge success and was soon supplying desserts to coffee shops like Starbucks and Caribou Coffee. The Dessert Place operated in Virginia-Highland until 2000. Sheryl Meddin's husband, Stuart, overcame his initial reservations about investing in the neighborhood and bought the northwestern corner of the Virginia-Highland commercial district from Irene Croft in 1983. Stuart had grown up in Charleston, South Carolina, and appreciated the potential of the historic retail area. He participated in and supported neighborhood commercial zoning in 2008 and the neighborhood master plan in 2014. (Courtesy of Sheryl Meddin.)

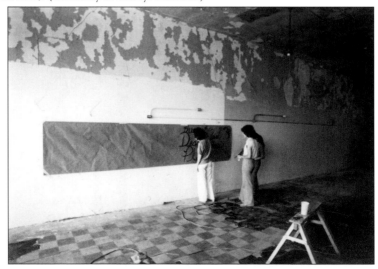

Tom Murphy got his start selling hot dogs at the Peachtree Battle Shopping Center and ran a cheese shop while in college. In 1980, he opened Murphy's Round the Corner in the basement of 1019 Los Angeles Avenue and moved 13 years later to the southeast corner of Virginia and Highland Avenues. Murphy has, for 20 years, operated a restaurant that has consistently received excellent food reviews. (Courtesy of Tom Murphy, Schroder Media.)

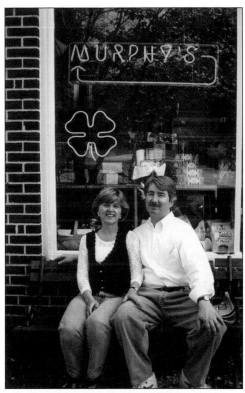

American Roadhouse was opened in 1989 by Martin Maslia (whose wife taught at Morningside) and Ed Eudoff, at 842 North Highland Avenue. With very community-conscious owners—supporting youth baseball teams, celebrating kids' birthdays, and offering wooden nickels that could be traded for milkshakes—it quickly became a popular hangout for families, local law enforcement, and breakfast meetings. (Courtesy of Amy Reel.)

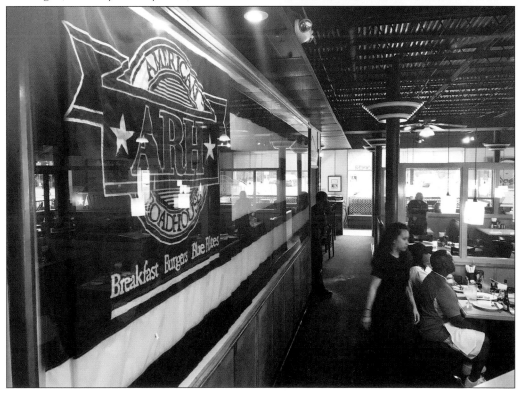

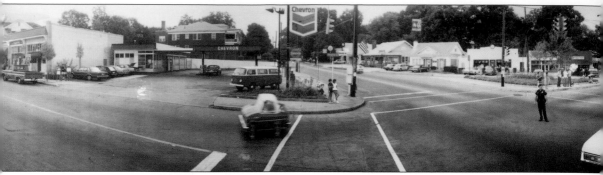

This 1982 photograph of the intersection of Virginia and North Highland Avenues by "Panorama Ray" (onetime Virginia-Highland resident Ray Herbert Jr.) captures the vibrant character of Virginia-Highland. By the 1980s, the area was an entertainment destination for all of Atlanta; it also began to experience a comeback in homeownership. Vic Matich, who moved to the area from Sandy Springs in 1975, owned businesses and rental properties in the area. Matich stored furniture for his rental properties in a building at the intersection of Virginia and North Highland

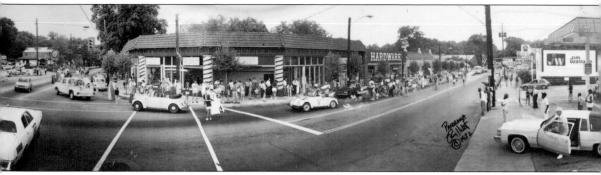

Avenues. Locals and visitors noticed him moving furniture from the warehouse and began to ask to buy pieces. Seeing an opportunity, Matich and his wife opened 20th Century Antiques on North Highland Avenue. The store was so popular it attracted top interior designers, pickers, stylists, and celebrities. Many stories of entrepreneurial successes abound in Virginia-Highland. (Courtesy of Herbert Ray Jr., www.PanoramaRay.com, and Dani Miller.)

Charles Henson (pictured at right) opened the Atlanta Book Exchange in 1976. Henson and his employees, including Jim Degnan (who worked there for three decades), were well-read and thoughtful, and the store made money until 2001, when the Internet took its toll. The store had an enormous, diverse, and barely sorted inventory, which was both part of its charm and sometimes frustrating. It closed in 2007. (Courtesy of Charles Henson.)

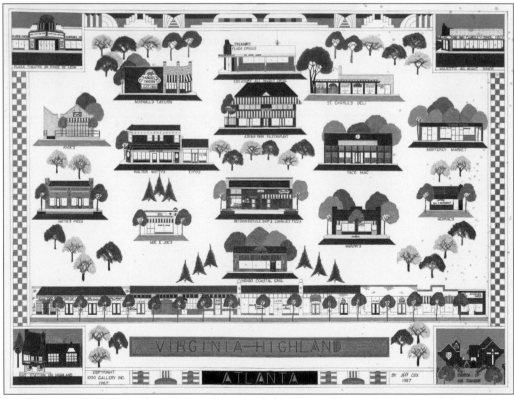

Jeff Cox owned 1030 Gallery, Inc. and created this poster illustrating many of the shops in Virginia-Highland. Some—like Mooncake (1979–2012)—arrived when the neighborhood was just gaining popularity. LA Auto Parts, open through 1989, is visible at the bottom right of the streetscape; to the left of it are 20th Century Antiques, the Purple Parrot, and Mitzi & Romano, which operated from 1987 until 2013. (Courtesy of Jeff Cox.)

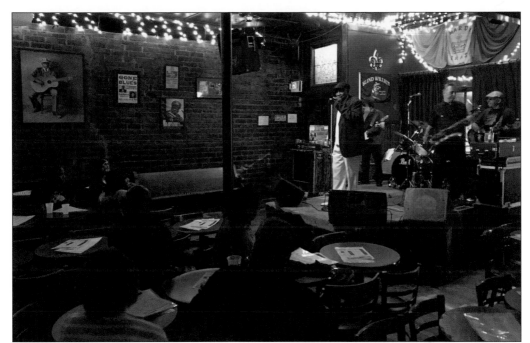

In 1986, music lovers Roger Gregory and Eric King opened the blues club Blind Willie's, at 828 North Highland Avenue. Depending on who is asked, the name honors either the legendary Atlanta blues musician Blind Willie McTell himself or all generic "blind Willies." A classic and unpretentious, smoky hole-in-the-wall music joint, it has hosted legends Grady "Fats" Jackson, Chick Willis, Sandra Hall. Roy Dunn, "Chicago" Bob Nelson, Billy White, John Hammond, Wild Child Butler, Carrie Bell, and many others. In the photograph above, singer George Hughley performs with the club's house band, the Shadows, who have been there since the beginning. McTell's photograph graces the wall. (Above, courtesy of Amy Reel; right, courtesy of John Becker.)

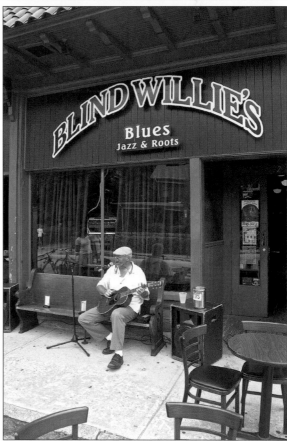

Virginia-Highland attracted many trending retail stores that appealed to a younger demographic looking for unique items one could not find at every mall in Atlanta. Bill Hallman's shop, in the Atkins Park area on North Highland Avenue, offered designer clothing and accessories from the early 2000s to 2015. The closing of Hallman's shop, and others like it, worries nearby businesses and property owners and remains a topic of neighborhood concern. (Courtesy of Tom Beisel.)

In 1989, Beth Marks and Sarah Gillett relocated Babes in Highland from Poncey-Highland to 1030 North Highland Avenue and changed the store's format from consignment to an upscale retail children's store; the business operated for a decade. Marks and her husband, Jett, have lived in the area since the early 1980s and are energetic volunteers to this day. (Courtesy of Beth and Jett Marks.)

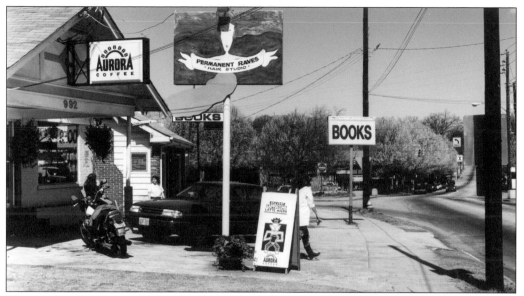

The retail coffee shop wave hit North Highland Avenue in the 1990s; at one point, five retailers were operating. Caribou (now Osteria) and Starbucks (now Marco's) were the first to go. The 2013 departure of Aurora (founded by Nina Laden and Booth Buckley in 1992) was especially painful. Its regulars subsequently roamed the neighborhood like displaced persons. In 2016, Press & Grind arrived; it was about time. (Courtesy of AP/AJC.)

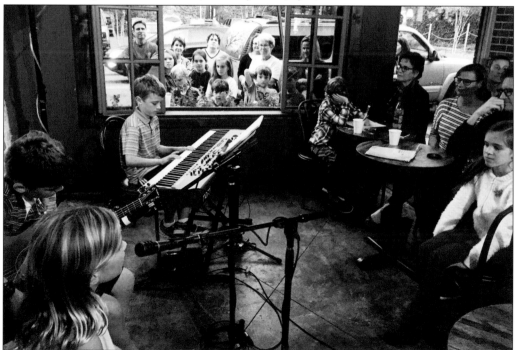

Founded in 1993 and still operated by Doug and Tanya Bond, the popular San Francisco Coffee, at Amsterdam and North Highland Avenues, remains a neighborhood fixture and the site of many political meetings. Its popular Sundays at San Fran, begun in 2012, offers the community's young children and teens a chance to showcase their musical talents. (Courtesy of Jenna Mobley.)

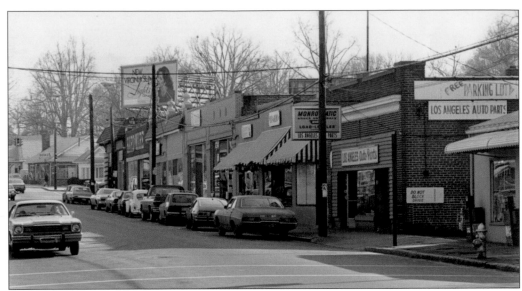

The gradual departure in the 1980s and 1990s of specialized retail products like window shades and auto parts (LA Auto, top right in 1989) reflected the growing costs of operating in a trendier and more expensive retail environment. The greater profit margins provided by the sale of alcohol made restaurants and bars a more promising investment. Property managers and business owners have faced difficulties in maintaining a broad mix of retail and food businesses, a challenge magnified by the 2012 Park Atlanta contract that brought strict enforcement of metered parking to Virginia-Highland, which competitors in nearby Morningside and Inman Park did not face. (Above, courtesy of AP/Louie Favorite; below, courtesy of Tom Murphy, Schroder Media.)

Warren Bruno, owner of Atkins Park Restaurant and Bar, started Summerfest in 1984 to promote the North Highland Avenue retail area. After VHCA assumed leadership of that event, Bruno and his wife, Sandra Spoon, led the 1993 formation of the Virginia-Highland Business Association (VHBA). It had 100 members in the first year, coordinated two progressive dinner parties for hotel concierges, and started A Taste of Virginia-Highland with over 18 restaurants participating. VHBA was active for many years but disappeared in the mid-2000s. Efforts to revitalize the business association in later decades have been more problematic. The health of the commercial nodes was also an area of focus for the master plan in 2014. (Right, courtesy of Sandra Spoon; below, courtesy of Dani Miller.)

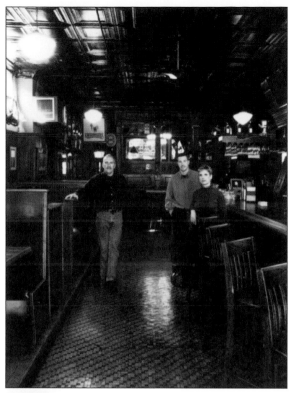

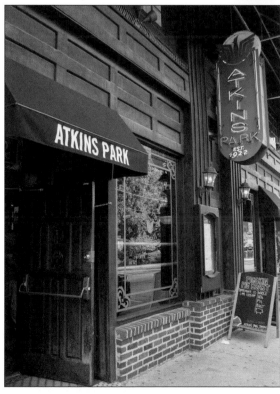

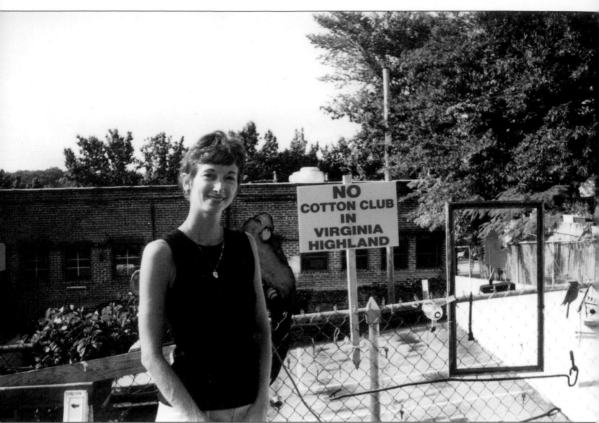

In 1999, several developers proposed converting the old Hilan Theater into a 700-seat live entertainment venue, the Cotton Club. The facility had a major parking challenge and appeared far too close to residences, a problem that the developers tried to solve by using bank queue lines in the hallway and including the sideways footage in the distance calculation. A huge gathering of neighbors, including councilwoman Cathy Woolard, filled the Virginia-Highland Church in opposition. The Atlanta Police Department was responsible for calculating distances on liquor permits; it measured in straight lines and concluded the obvious—the alcohol beverage code was not being followed. After much bluster and complaining, the developers withdrew the application. Their indifference to residential interests left an atmosphere of mistrust that was slow to dissipate. (Courtesy of Kim Griffin [pictured] and Rufus Stansell.)

Six

SUCCESS HAS ITS STRESSES

SOMETHING TO PROTECT

The increase in pedestrian traffic and commercial growth at Virginia and Highland Avenues made obvious the need for safety and traffic controls. Highland Corridor Improvement Project (pictured in progress) widened sidewalks, installed tree wells, and intentionally restricted the slip lane in front of Taco Mac's, making that space far safer for pedestrians. The adjacent triangle, with new sitting walls facing the corner, was redesigned and replanted. (Courtesy of Rufus Stansell.)

The built environment was a formal topic of discussion in the neighborhood by the early 1980s and remains one over three decades later. In 2005, Virginia-Highland was placed in the National Register of Historic Places, a status without specific protections but a marker of the area's definitive character. The minimal changes made in the Atkins Park subdivision over the decades (original plat below) gave residents a great opportunity to qualify for City of Atlanta Local Historic District protection. Longtime residents, from left to right, Marilyn Morton, Linda Guthrie, and Mary Chance (pictured at left) led that process to overwhelming approval in 2007. Its regulations restrict teardowns and regulate renovations. Years later, they noted their good fortune in acting before the era of mass social media and the easy spread of misinformation. (Left, courtesy of Robin Davis; below, courtesy of VHCA.)

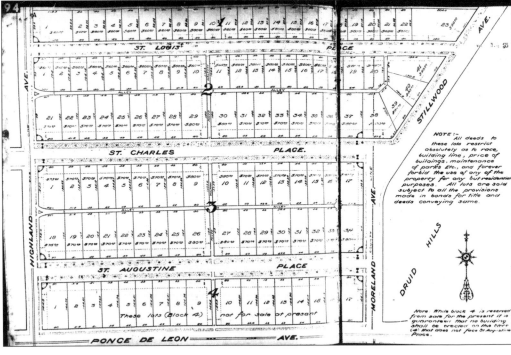

Preserving the urban canopy has been a contentious topic in development-centric Atlanta for decades. Marcia Bansley founded Trees Atlanta in 1985 and slowly convinced the reluctant administration of Mayor Andrew Young to plant trees on downtown streets. Greg Levine arrived at Trees Atlanta a decade later and dramatically expanded the organization's outreach into neighborhoods. By the mid-2010s, it had planted over 100,000 trees in the city. Nearly 3,000 of those were in Virginia-Highland, an effort begun in the 1990s by resident arborists Stephanie and Tom Coffin. Stephanie also led a decades-long effort to improve utility tree-trimming practices. Tom, who had a PhD from the Warnell School of Forestry at the University of Georgia, was an arborist for the city, which often seemed more vexed than pleased by his careful enforcement of its own laws. (Above, courtesy of Tom Coffin; below, courtesy of Trees Atlanta.)

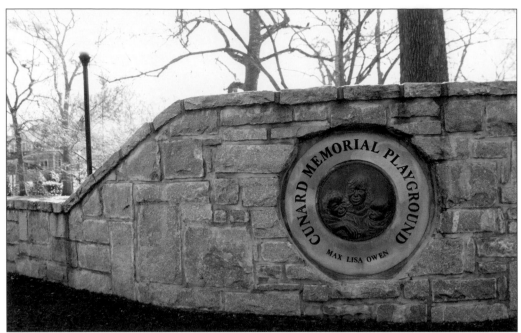

In July 2003, an oak tree fell across the Cunard family car sitting in traffic on North Highland Avenue. Atlanta Fire Station 19 was 100 yards away and responded immediately and heroically but were unable to save Lisa and her two children. Brad Cunard, sitting inches away, was physically unhurt. The stunned neighborhood responded with a memorial playground in their honor at John Howell Park, which includes a small replica of fire engine 19. Low granite walls now separate the play area from John Howell's renovated volleyball courts, which also function as the city's largest children's sandboxes. (Above, courtesy of Robin Davis; below, courtesy of Karri Hobson-Pape.)

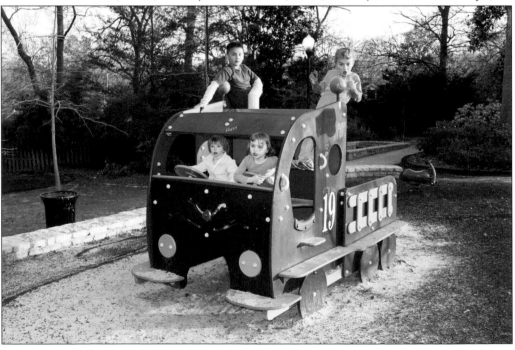

The intown boom coincided with a decrease in city funding for parks. In 1984, a group of local citizens created the Friends of Piedmont Park, an advocacy model that would be emulated throughout the city over the next decades. The city's baffling 1990 proposal to fill the area behind Park Tavern with an aboveground sewage treatment plant galvanized public opposition and led Maynard Jackson to quash the idea. Piedmont was the center of controversy again 12 years later when the Atlanta Botanical Garden ignored the objections of 21 NPUs and built a road through the park to its new parking deck; over 70 trees were removed in the process. In 1992, the Piedmont Park Conservancy established a public/ private partnership with the city modeled on Central Park. The conservancy has championed many renovations in the park. (Right, courtesy of Jack White; below, courtesy of Nic Huey.)

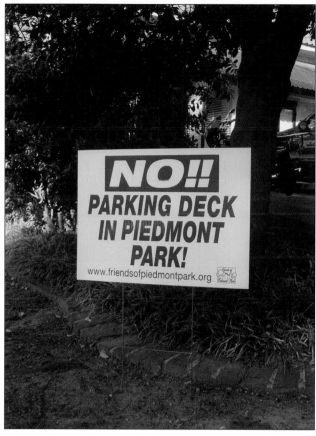

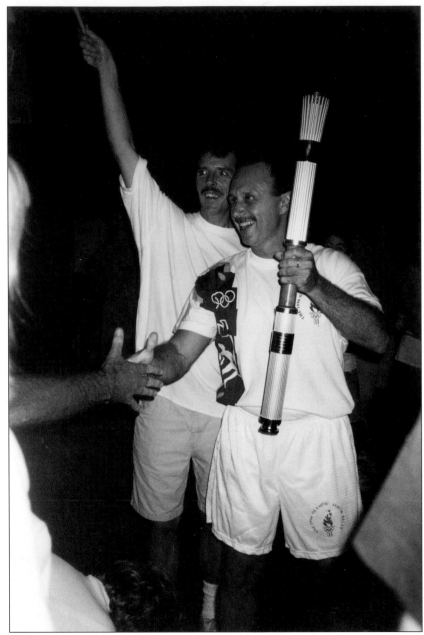

Atlanta's 1996 Centennial Olympic and Paralympic Games were introduced by the torch's national journey, which came down North Highland Avenue the night before the opening ceremony. A large crowd waited for hours and was entertained by several late-night streakers (with faux torches) who ran down the middle of the street as the torch was approaching. Jerry Bright (right) was one of the official torch bearers. Virginia-Highland's intown location made it accessible and popular with athletes and visitors; local bars and restaurants were close to the venues and the Olympic Village at Georgia Tech. Residents rented out their homes in large numbers. The city's much-feared logistical nightmare never materialized; with many downtown roads closed and free public transportation, traffic moved smoothly through the city. Studies later showed that Atlanta's air quality had improved dramatically during the games. (Courtesy of Jerry Bright.)

Young families in Virginia-Highland in the 1970s and 1980s had few commercial choices for childcare; supporting each other in raising and educating their kids was a priority. Nancy Hamilton and Ann Roark started a babysitting co-op with a novel twist—credits in the form of chits earned by providing childcare. In the 1990s, Virginia-Highland saw an influx of new families. One parent, Karen Page, took advantage of the latest technology and started the neighborhood's first online community for parents, the Virginia-Highland Morningside Parent Association (VHMPA), in 1998. VHMPA has grown to almost 1,000 families. (Above, courtesy of Nancy Hamilton; left, courtesy of Lola Carlisle.)

The charming and cozy original branch of the Atlanta Public Library, at North Highland Avenue and St. Charles Avenue, was replaced in 1990 by a larger and more functional building at Frederica Street and Ponce. Both locations have been among the city's busiest; a generation of enthusiastic and beloved librarians have run programs for children and adults. Longtime branch manager Bill Munro was a Virginia-Highland resident. (Courtesy of John Becker.)

In 2006, Pamela Papner (at center in the previous image) led VHCA's purchase of the original library site, which had sat vacant for years. North Highland Park became the neighborhood's third park and the site of community functions, lawn parties, and wedding ceremonies. Assuming an $800,000 debt was a daring responsibility and required a decade of arduous and unrelenting work on fundraisers like Summerfest and the Virginia-Highland Tour of Homes. (Courtesy of Jess Windham and Jonathan Stout.)

By 1976, enrollment at Morningside Elementary—then serving Virginia-Highland and other intown communities—had dropped to 158 students. The downward trend reversed itself dramatically in the 1980s; by 2000, Morningside's campus was dotted with trailers trying to accommodate its suddenly booming student body. It was a time of political and financial disarray within Atlanta Public Schools, whose once decorated school superintendent would later be indicted on racketeering charges involving falsified test scores. (Courtesy of Karri Hobson-Pape.)

Atlanta Public Schools' 2009 transfer of Virginia-Highland's children to the brand-new Springdale Park Elementary School made logistical sense but caused considerable community angst. Led by a skillfully run and energetic Parent-Teacher Organization, parents responded with a burst of organizational energy on administrative, educational, technical, and structural fronts, providing curricula addenda, a new playground, a rooftop garden, and beehives. In 2016, Atlanta Public Schools transitioned to a charter system, providing parents with some administrative input. (Courtesy of Lola Carlisle.)

Warren Bruno founded Summerfest in 1984 as a promotion for Atkins Park Restaurant and Bar and other businesses along North Highland Avenue. The original event included music, tastings, sidewalk sales, and a 5K race, whose route was marked by a trail of flour. It soon morphed into a larger end-of-school community celebration and has been run by VHCA since 1989. Pamela Papner directed it for over a decade beginning in 2006 and transformed it into a major fundraiser, whose proceeds helped pay for a new park, school and community grants, and planning efforts. Atkins Park Restaurant and Bar has served a community dinner at the event since 2005. Bruno's many friends memorialized his passing in early 2012 by quietly marking that year's festival site with his mantra, "Allow. Accept. Appreciate." (Left, courtesy of Drew Graham; below, courtesy of Karri Hobson-Pape.)

The Atlanta Parks Department maintenance budget shrank in the 1990s and 2000s. The addition of the Cunard Playground masked the wear and tear in other areas of John Howell Park, which by 2011 were drawing public comments; the sandbags along the volleyball courts were especially unpopular. Over the next few years, the VHCA Parks Committee, led by David Brandenberger and Lauren Wilkes Fralick, wrote and received two new matching grants from Park Pride. Native plant expert Walter Bland (whose tall grasses line the northeast BeltLine) and Peter Frawley (the park's original landscape architect) coordinated a massive rehab effort that removed invasives, reduced erosion, and installed new plants, trees, and rain gardens around the park. Granite walls and wrought iron fencing were built around the volleyball courts. A second project in 2017 added walls along Virginia Avenue and made other landscape improvements. (Both, courtesy of John Becker.)

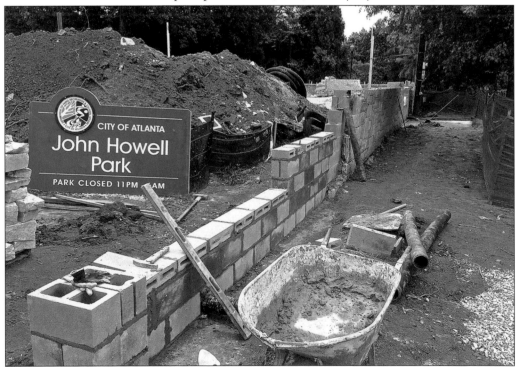

After several years of operating from his Virginia-Highland home, in 1985 Mike Goodman opened Intown Bicycles at 1186 North Highland Avenue, next to Camille's Restaurant. (El Taco now occupies both spaces.) The popular shop moved to a larger space on Monroe Drive (100 convenient yards north of the future BeltLine) in 1994. Intown's steady growth signaled the end-of-the-century boom in cycling. By 2016, a second cycling shop, Atlanta Pro Bikes, had opened in Virginia-Highland. (Courtesy of Mike Goodman.)

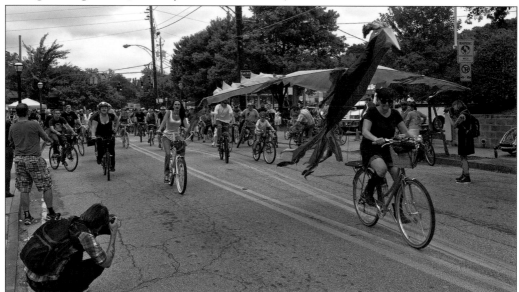

The very effective Atlanta Bicycle Coalition (founded in 2011) created the highly successful Streets Alive events that were hugely popular in Virginia-Highland and other neighborhoods. Cycling's growth was very visible at Inman Middle School, whose bike capacity doubled in the early 2010s, and was reflected in the master plan's call for bike lanes along St. Charles and Virginia Avenues. The formal opening of the BeltLine's Eastside Trail in 2014 further increased ridership. (Courtesy of John Becker.)

Seven

INVESTING IN THE COMMUNITY

THE ERA OF FORMAL PLANNING

Virginia-Highland's name and identity were created in the 1970s in response to a threatening highway. Four decades of reacting to zoning and development challenges slowly made clear the need for community-based planning. Working with professional planners gave citizens a chance to develop their own vision and the opportunity to be effective in complex planning environments. It also necessitated proportional fundraising efforts. The process began in 2007 along North Highland Avenue and now includes the entire neighborhood. (Courtesy of Nic Huey.)

plan

Protect Livable
Atlanta Neighborhoods

The redevelopment boom of the early 2000s spurred a wave of teardowns and infill McMansions all over the city. Public opposition in early 2006 led Mayor Shirley Franklin and the city council to impose moratoriums on teardowns while the issue was examined. Councilwoman Mary Norwood took the lead in a series of public hearings around the city that included residents, developers, realtors, architects, and planners. The changes that emerged, known informally as the "infill" or "Norwood" ordinance, were adopted by the city in the summer of 2007. Key regulations restricted average height to 35 feet, refined the determination of floor area, and closed some loopholes on lot grading. The changes were a balm but hardly a cure. (Above, courtesy of PLAN; below, courtesy of Lola Carlisle.)

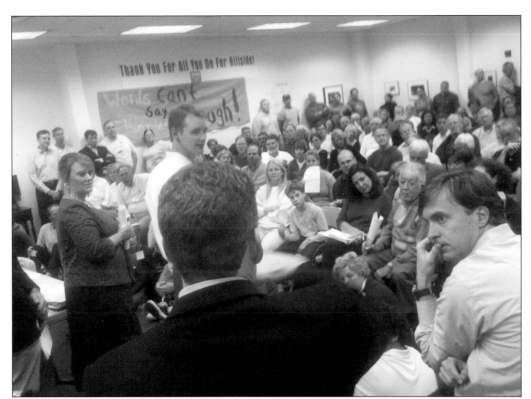

A 2006 attempt to construct a six-story mixed-use structure opposite the American Roadhouse was a turning point in Virginia-Highland's approach to commercial development. Citizens learned only incidentally of the proposed building, which was twice as high as any on the street. Vigorous community opposition filled the Inman school auditorium on a June evening. That fall's new board and planning committee undertook a professional (and focused) approach to future land use. The result was a two-year public process led by city planners Aaron Fortner and David Green that resulted in the city's 2008 adoption of neighborhood commercial zoning along North Highland Avenue. Approved by owners and residents, it addressed parking by zone and limited heights to 42 feet. Fortner and his legal colleague Bob Zoeckler would be instrumental in shaping the association's planning over the next decade. (Both, courtesy of Lola Carlisle.)

Virginia-Highland
Neighborhood Preservation
Committee
A subcommittee of the Virginia-Highland Civic Association

Proposed Design Guidelines for the Virginia-Highland Historic District

The ease of obtaining demolition permits incentivized many owners to raze (rather than repair) homes in the area. In 1982, VHCA president John Howell led the neighborhood's successful effort to become an Urban Conservation District, whose processes limited teardowns. A 1989 revision of the ordinance dropped that requirement. Atkins Park was listed in the National Register of Historic Places in 1983, as was Virginia-Highland in 2005. Two-thirds of respondents to a 2007 controlled resident survey by the VHCA Preservation Committee supported the exploration of historic designation. VHCA's commitment to buy North Highland Park exhausted the group's funding, and the preservation effort ended. In 2013, local citizens initiated a study of a design district concept, which is still under examination by the city's Planning Department in its pending rewrite of the zoning code. (Both, courtesy of VHCA.)

As the economy slowly recovered from the financial recession of 2007–2009, a wave of residential development pressure led the VHCA board to consider a master plan to protect the neighborhood from—as Aaron Fortner put it—"being loved to death." Fortner led the process, which included reviews of existing plans, specific resident surveys, interviews with commercial interests, and studies of transportation, congestion, and mobility issues. Multiple committees met with city planners and experts in several fields, and a series of public forums and input sessions were held. After reviews and revisions, the 118-page final document was adopted by the board in the summer of 2014, approved by the NPU, and—with council member Alex Wan's support—added to the city's master plan that fall. (Both, courtesy of Lola Carlisle.)

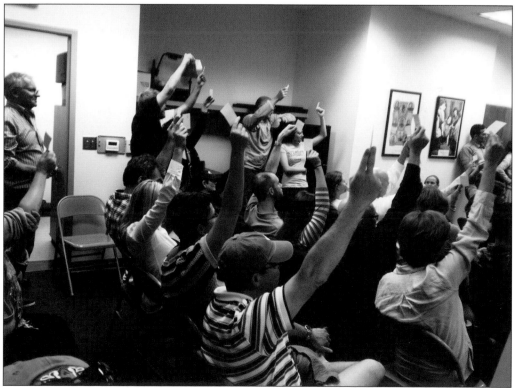

By the mid-2000s, Monroe Drive was handling more than 20,000 vehicles per day. Traffic that crawled at rush hour and zoomed at other times—and 10 left-turn opportunities in a half mile—made for numerous nasty accidents and frazzled many neighbors. The 2014 cycling death of Grady High School student Alexia Hyneman, on Monroe Drive, personified everyone's worst fears. Planners argued that the speed and volume of traffic were inconsistent with single-family residential status and would incentivize much denser development all along Monroe Drive. Traffic studies from the Renew Atlanta process suggested that a reduction in lanes from four to three (one each way with a shared middle turn lane) would move almost as much traffic at a safer speed and reduce accidents. The counterintuitive approach became a lightning rod for frustration over the city's poorly regulated growth, lack of planning, and increased congestion. (Courtesy of Nic Huey.)

The replacement of older homes (like the one featured above) with larger structures, bigger accessory buildings, expanded hardscapes, and the loss of many older trees combined to produce notably larger volumes of storm water. VHCA was a persistent and voluble advocate of the city's 2013 Stormwater Ordinance, Atlanta's first attempt to retain runoff on-site. That law—and a more vigorous city effort on erosion at construction sites—has eased but hardly ended the problem, as the photograph below (taken in 2017) suggests. The city was also forced to drop its decades-old policy of allowing construction atop underground wastewater lines, which are gravity-fed and are often parallel to creeks. The age and condition of many of those lines remains a concern. (Both, courtesy of Lola Carlisle.)

Atlanta Fire Station No. 19 (FS19) was built in 1925 with a host of Craftsman-style elements, overhanging eaves, brackets, and a hipped roof dormer. Its professional achievements are noteworthy—FS19 fought the horrific Winecoff Hotel fire in 1946 and was first on the scene at the collapse of I-85 in 2017. Its role as a community institution offering tours to children, blood pressure monitoring, and car seat checks has endeared it to generations of residents. The city's 2015 designation of the station for future replacement stunned citizens. Council member Alex Wan and VHCA board member Catherine Lewis (a professor of historic preservation) led a planning and fundraising effort to renovate the historic structure. Doc Chey's, Osteria, Tailfin, and others businesses raised over $100,000; Wan coordinated city efforts and funding with his trademark dexterity. Historic architect Tom Little of Surber Barber Choate + Hertlein was lead architect. (Both, courtesy of Lola Carlisle.)

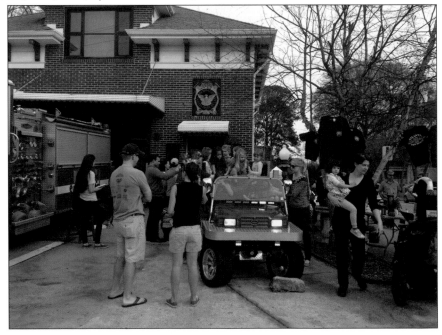

The first Europeans to settle in the Virginia-Highland area were Richard and Martha Todd, in 1822. They built a house at today's 816 Greenwood Avenue; the family cemetery was in the rear of 795 and 797 Ponce de Leon Terrace. The first known burial was that of Richard in 1851. Homes were built on the lots in the 1990s, and a memorial to the Todd family was established in the rear of 797 Ponce de Leon Terrace. The memorial included a marker (above), placed in the cemetery by Todd descendants in the late 1920s. The public peacefully visited the memorial for years. In 2015, the memorial was removed by the property owners and the marker was damaged. After a legal battle, an agreement was reached to reestablish the memorial in a local park and incorporate the historic marker. (Above, courtesy of Mike Zarrilli; below, courtesy of Jack White.)

The Atlanta BeltLine grew from Georgia Tech grad student Ryan Gravel's concept of converting a loop of abandoned intown railroad lines into walking and cycling paths, light-rail transit, and parks. The demand for alternatives to cars in Atlanta is unmistakable; the northeast trail was filled with cyclists and walkers even before it formally opened, and it still is. The Lantern Parade (left) began in 2012 with 1,500 participants; by 2016, it was a 60,000-person spectacle of lights and sounds. The concept of connecting diverse neighborhoods resonated in a city that has historically been divided by race and class, but funding has been slow to arrive. No rail has been built or scheduled, and the new development along the BeltLine's northeast trail in already gentrifying Virginia-Highland has deepened concerns about affordable housing. (Above, courtesy of Dani Miller; left, courtesy of Karri Hobson-Pape.)

Afterword

Ecological research reveals that the health of an ecosystem is directly related to the degree of biodiversity present within the community. The same principle applies to human community. The communities we build and inhabit are human ecosystems, and the neighborhoods we live in are best for us when they are diverse. In their best form, these are the places where the various stages of lives are accommodated, where we can move from one life situation to another without having to leave. We can be children, students, singles, adults, couples, families, empty nesters, or caretakers all within the same community if we choose to do so. It is profoundly good for a neighborhood when teachers can live in the same community as their students, grandparents with their grandchildren, civil servants in the community they serve—where the bar owner, the bartender, and the barfly can go home and be neighbors.

These healthy places offer multiple safe, comfortable, and engaging modes of travel that make driving nonessential at best or pleasantly tolerable at worst. They give us abundant and abounding ways to work, live, move about, and recreate. This healthy good-for-our-souls, almost too-good-to-be-true neighborhood is Virginia-Highland. Virginia-Highland aspires to be a place of mobility diversity—where residents walk, take a train, or bike to work in Midtown, downtown, Decatur, or Buckhead in 20 minutes or less. Virginia-Highland will be a place of dwelling diversity—where a child can grow up in community and come back to it later in life, moving fluidly from renting to owning or from a small to large home. Virginia-Highland will be a place of environmental diversity—where one can find relief from the city by strolling through urban forest, creek and stream trails, community gardens, parks with sunbathers and volleyballers, and people-filled plazas, all to the soundtrack of a symphony of birds and wildlife.

—Aaron Fortner
Canvas Planning Group

DISCOVER THOUSANDS OF LOCAL HISTORY BOOKS
FEATURING MILLIONS OF VINTAGE IMAGES

Arcadia Publishing, the leading local history publisher in the United States, is committed to making history accessible and meaningful through publishing books that celebrate and preserve the heritage of America's people and places.

Find more books like this at
www.arcadiapublishing.com

Search for your hometown history, your old stomping grounds, and even your favorite sports team.

Consistent with our mission to preserve history on a local level, this book was printed in South Carolina on American-made paper and manufactured entirely in the United States. Products carrying the accredited Forest Stewardship Council (FSC) label are printed on 100 percent FSC-certified paper.

MADE IN THE USA